Architectural Photography

To
Billy
with love

Architectural Photography

Michael G. Harris

Focal Press
An imprint of Butterworth-Heinemann Ltd
Linacre House, Jordan Hill, Oxford OX2 8DP

 A member of the Reed Elsevier plc group

OXFORD LONDON BOSTON
MUNICH NEW DELHI SINGAPORE SYDNEY
TOKYO TORONTO WELLINGTON

First published 1995

British Library Cataloguing in Publication Data
Harris, Michael G.
 Architectural Photography
 I. Title
 778.94

ISBN 0 240 51377 0

Library of Congress Cataloguing in Publication Data
 Harris, Michael G.
 Architectural photography/Michael G. Harris.
 p. cm.
 Includes bibliographical references and index.
 ISBN 0 240 51377 0
 1. Architectural photography. I. Title.
 TR659.H38 1995 94-32564
 778.9'972–dc20 CIP

Composition by Genesis Typesetting, Laser Quay, Rochester, Kent
Printed and bound in Great Britain by Hartnolls Ltd, Bodmin, Cornwall

Contents

Preface

The subject matter of the architectural photographer is the structure of buildings, both inside and out. Photographers frequently describe their specialization as 'architectural and interiors', thereby making a distinction between architectural photography which is primarily concerned with the structure of buildings, and interior photography which concentrates on the content and interior design.

This book is written as a companion volume to my earlier work, *The Manual of Interior Photography*, in which all aspects of interior photography are explained in detail. Consequently, it concerns itself chiefly with the photography of exteriors, the outside of buildings, while still outlining the main principles of interior photography that are applicable to architectural work.

'Architecture' is defined by dictionaries as the art and science of building construction, and 'photography' as the art or process of producing pictures by the action of light on chemically sensitized film. What is clear from these two definitions is that architecture and photography share the common characteristic of being both art and science at the same time. This is very significant, as neither is a merely functional practice, and truly inspiring architectural photography is the result of a competent practitioner responding aesthetically to the harmonious construction of the architecture he or she is photographing.

This book, therefore, aims to teach the theory and practical techniques that underlie this specialist branch of photography, as well as to explore the aesthetic laws behind both the construction of buildings and, more importantly, their favourable recording on film.

Michael G. Harris

Acknowledgements

A book is rarely the product of one person's endeavours, and this one is no exception. While I have been directly responsible for the content, I have had tremendous support for this project from my family, friends, publishers, clients and suppliers alike. Accordingly, I should first like to thank my family: Val, my wife, and my children Leo and Billy for affording me both the opportunity and time to undertake this project, and also my parents for their continuing encouragement.

My thanks go also to Margaret Riley, my commissioning editor, for her unerring enthusiasm and ever-willing assistance in the production of this book.

My clients have unwittingly been the source of much of the photographic material seen here, and have all been supportive of the idea. I would especially like to thank, for their kind cooperation, Andrew Clark and Alastair Walker of The Alan J. Smith Partnership, architects of the Nissan European Technology Centre (NETC) near Milton Keynes which has served as a model example of outstanding modern architecture for purposes of illustration throughout this book.

The clients whose work is featured in the final chapter include Dave Watkiss of Kingsway Advertising, David Humphrys of The Creative Consultancy, Carol Cavanagh and Chris Rowell of The Alphabet Design Partnership, and Andrew Barrs, John Reavley and Simon Holley of Brian Cooper and Company, to whom I wish to extend my thanks. I also very much appreciate the kind permission of Mike Dickson of Spen Hill Properties to reproduce the photograph of St John's Place on the cover, and also the brochures of St John's Place and St Mary's Court as colour plates.

My warm gratitude goes to Horst Pientka of Linhof cameras in Munich who has always been willing to grant permission for the publication of Linhof material, both technical and photographic. Also, to John and Lorna Saunders and Terry Cross at Cascade Colour Services, John Farnham for his excellent black-and-white printing and photographic friendship, and the staff of KJP for their assistance and efficient supply of photographic materials.

Finally, I am indebted to Sam Booker and David Dewhurst for their astounding 'sun finder' charts, originally published in Richard Platt's *The Professional Guide to Photo Data* (Mitchell Beazley, 1991), and reproduced here in the Appendix. I also wish to thank the publishers of K. W. Smithies, Herbert Read, Paul Oliver and Richard Hayward for their permissions to quote from their works, and to acknowledge the memory of one of the very first architectural photographers: Frederick H. Evans (1853–1943).

All the photographs in this book were taken by the author unless otherwise specified.

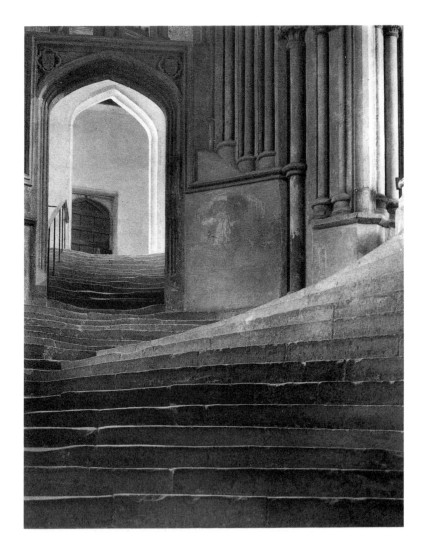

Figure I.1 'The Sea of Steps', Wells Cathedral, Frederick H. Evans, 1903 (courtesy of The Royal Photographic Society). '. . . I succeeded in getting a negative that has contented me more than I thought possible . . . The beautiful curve of the steps on the right is for all the world like the surge of a great wave that will presently break and subside into smaller ones like those at the top of the picture. It is one of the most imaginative lines it has been my good fortune to try and depict, this superb mounting of the steps . . .' – Frederick Evans in *Photography*, 18 July, 1903

Introduction

... it is not everyone who has the time to see a building in all its phases of beauty and effect, or has the power of isolating those beauties, and so realising the more subtle and recondite charms a great building has, but gives up only to patient study and trained observation ...

Frederick H. Evans (1853–1943), architectural photographer, in the address he gave at the opening of his exhibition at the Royal Photographic Society in London, on 25 April 1900.

'Patient study and trained observation' must be the foundation stones of successful architectural photography, along with sufficient technical knowledge and experience to be able to reproduce on a mere sheet of photographic film the 'subtle and recondite charm' of a building.

As a perfectionist art form, architectural photography is a methodical process demanding patience and clinical precision from its practitioners. It also requires a subtle aesthetic appreciation and an experienced understanding of the potential and effects of natural light – 'Realism in the sense of true atmosphere, a feeling of space, truth of lighting, solidity and perfection of perspective ...' (ibid.). Both viewing and especially producing accomplished architectural photographs can be a rich and immensely satisfying experience.

Architectural photography demands an appreciation of the function of a particular building along with the discovery of its sculptural qualities (especially with modern buildings) and exploiting these to their best advantage through judgement and control of lighting, camera viewpoint, and the selection of a lens of appropriate focal length.

Some of the best architectural photography can appear to the untrained eye as deceptively simple, as something anyone could take given a sunny day and a reasonable 35 mm camera. However, such perfect simplicity can usually only be achieved through a positive, informed understanding and interpretation of the building, precise composition, and the use of a specialist camera and lens. It also requires profound judgement of natural light through the predetermination of the position of the sun relative to the building for optimum sculptural relief, and perhaps subtle filtration. A 35 mm camera on a sunny day is suitable for many subjects, but architecture is not one of them. This would quickly become apparent by comparison of a 'simple' top architectural photograph and an equivalent

shot by an amateur on a 35 mm camera. In the latter, verticals in the image would be likely to converge, and there would be a general imperfection of the line dynamics due to inaccuracies caused by the inadequate size and clarity of the viewfinder (i.e. not composing the image directly onto a technical viewing screen).

Understanding the behaviour of natural light is a science in itself, and a crucial element of both successful architectural photography and the effective use of the photographer's time (which is of paramount importance in the running of any business). Being completely beyond the effect of human influence, working with natural light brings a primitive sense of fulfilment (and often frustration!) at the achievement of favourable results.

There is a wide variety of demands for architectural photography, notably for architects and construction companies, but also for property brochures, company reports, archives etc., in fact any situation in which a building needs to be photographed either for publication or as a record. This book outlines the fundamental theories and techniques at the root of all such work, though the emphasis the photographer places on certain elements or aspects of a building he or she is photographing is likely to change depending on the nature of the client and the brief. Architects are likely to be more interested in clean lines and clever, sometimes abstract, architectural features, whilst property agents will have a greater concern to show maximum floor space and car-parking facilities.

As a necessary preliminary to the practice of architectural photography, the book starts with a chapter on 'Architecture and architects'. The aim of this is to develop an understanding of the way architects go about designing a building, to come to terms with the language, and to generate an empathy for the important and sometimes subtle aspects of architecture. It will hopefully also create an awareness of the atmosphere of precision and technical excellence in which architects work and come to expect from others, not least the photographers they employ.

1
Architecture and architects

Introduction

Our appreciation of architecture is both an aesthetic and intellectual experience. Buildings can inspire us by their presence, and occasionally move us emotionally (as some who have visited the Taj Mahal in Agra, India will testify). They can also stimulate us intellectually through a basic understanding of the clever technology and skills that have been utilized in their construction.

An informed appreciation of architecture should generate a constructive awareness in the photographer's approach to a building, thereby enhancing the relevance and aesthetic value of his photographs.

The work of the architect

The work of an architect is to design buildings and supervise their construction. A simple definition for a task of immense complexity and variety, requiring a seven year training for the student architect to learn how to integrate the countless social, technological and aesthetic aspects involved in the design and construction of a building.

The student has to acquire a detailed knowledge of the physical laws and properties of a multitude of different materials and realize the construction possibilities of each material. An understanding of heating, lighting, ventilation and air conditioning has to be assimilated, along with the service requirements for buildings: water, electricity, drainage and sewage. He or she needs to develop an intellectual understanding of the history of architecture, and study the huge diversity of building types, from houses and offices to hospitals and factories, with their respective building and safety regulations. Not least, the student architect has to acquire the skills of a competent draftsman.

The role of the architect is that of creator and coordinator: creator of the design of visually satisfying, integrated buildings for specific purposes; and coordinator of their subsequent construction with the planners, engineers, and contractors. In this, the architect takes overall responsibility for monitoring their successful construction on site.

A recent history of architecture

Sir Christopher Wren, remembered most notably for rebuilding St Paul's Cathedral in London, is generally acknowledged as being the first professional English architect, probably the greatest, and certainly one of the most prolific. As Surveyor General of the King's Works, he was responsible for many of the major buildings in London, Oxford and Cambridge in the second half of the seventeenth century. Before this time, major buildings were the product of the combined achievements of patrons and their master masons. Houses and barns were built by craftsmen according to local tradition, using locally available materials. The legacy of such 'vernacular' architecture is the wonderful regional diversity of traditional buildings, from the granite longhouses of West Devon, and the stone cottages in the Cotswolds, to the variety of timber-framed buildings across the south of England. Vernacular architecture had admirable integrity both in its appropriate method of construction and in meeting the physical and social needs of the community.

The vernacular tradition in Britain died out in the 1840s as a result of industrialized techniques of brick-making, and the arrival of steam trains to transport the ready-made bricks around the country. This diminished the need to use local building materials, and with ever improving communications, eroded the regional variations of style.

The foundations of 'modernism' in architecture are rooted in the philosophy that developed as a result of the Industrial Revolution in the eighteenth century, that progress is made through ever increased rationalism, and therefore that 'form follows function'. Buildings were to be primarily functional, with the belief that when functional demands were fully met, beauty would be the inevitable outcome.

Architecture in the first half of the nineteenth century had been characterized by its indescriminate copying from all past building styles. However, in 1851, having successfully designed several large greenhouses for the gardens at Chatsworth House, Sir Joseph Paxton built his 'Crystal Palace' (Figure 1.1) to house the Great Exhibition. It is considered to be the first major 'modernist' building in Britain, exploiting recent technological developments to create a massive, steel-framed, glass structure 1800 feet in length. It was the first ever example of a building made from prefabricated parts with a modular design, enabling an assembly time of only four months.

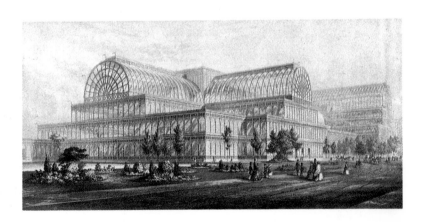

Figure 1.1 The Crystal Palace by Sir Joseph Paxton, built to house the Great Exhibition of 1851. It is considered to be the first major 'modernist' building in Britain

'Modernism' flourished throughout the first half of the twentieth century, reaching a zenith in the post-war period when concrete high-rise blocks had seemed to provide an egalitarian answer to Britain's problems of overcrowded industrial cities. However, working-class communities became fragmented by their development, depriving the inhabitants of the richness of an organically developed city.

As an international philosophy, 'modernism' was propagated most notably by the architects Le Corbusier, who believed a house should be 'a machine for living in'; Ludwig Mies van der Rohe whose theories of functional simplicity gave rise to his thesis that 'Less is more'; and Walter Gropius who founded the Bauhaus in 1919 as a meeting place for arts and crafts teaching, where artists and architects could work together towards 'the building of the future'. Improvements in communication (air travel and telecommunications) enabled the growth of an 'international modernist' style across the world: high-rise, slab-sided buildings of little character on an inhuman scale.

By the 1950s, disillusionment with functional rationalism started to set in. 'Public modernism' was superseded by 'corporate multi-national modernism' in the 1970s and 1980s, creating homogenous cityscapes in the major cities of the world. This left people yearning for buildings richer in form, detail and decoration to which they could relate.

As a result, we are now living in an era of 'postmodernism', a term which embraces a pluralism of discontinuous movements all with an emphasis on complexity as opposed to simplicity. The movements strive to produce meaningful architecture that is 'double-coded', i.e. that is communicative both to the members of the professional elite (as with modernism), but also, significantly, to the general public who have to live with it. As a result, postmodern architecture can be irreverent in its use of

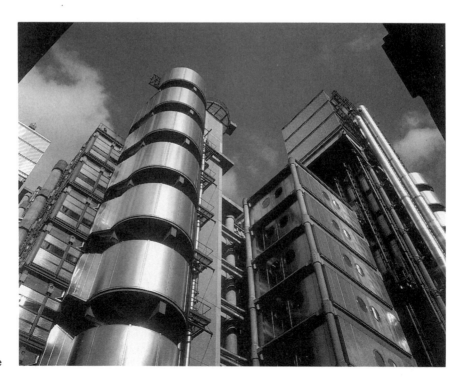

Figure 1.2 Lloyds Insurance building, City of London, by Richard Rogers. A fine example of 'high-tech' architecture

motifs from the past, and thereby differs from the neoclassicism of architects like Quinlan Terry.

'Postmodern' styles range from the 'hi-tech' architecture of Norman Foster and Richard Rogers (noted for his Lloyds' Insurance building in the City of London, Figure 1.2), to the 'neoclassical' of Ricardo Bofill and James Stirling.

Design drawings

The tools with which the architect expresses his ideas to the outside world, and which are used as the detailed plans for the construction of his buildings, are his design drawings. It is useful for the architectural photographer to have an understanding of the terms used, and be able intelligently to interpret the drawings. A cursory glance at any architectural drawings will generate an awareness of the standards of perfection and accuracy to which architects have to work.

The main types of design drawing are outlined below.

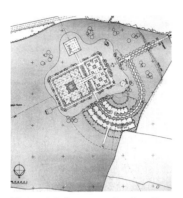

Figure 1.3 An example of a site plan. This is a preliminary site plan for the Nissan European Technology Centre (NETC) at Milton Keynes by The Alan J Smith Partnership, a building I have used for purposes of illustration throughout this book

- *Plan.* The plan is a map of the proposed building, showing a horizontal plane cut through a building at a height of about 1 metre above ground in order to show the position of doors, windows, internal walls etc. It can also be used to show the positioning of furniture.
- *Site plan.* The site plan is a map showing how the building relates to the land on which it is to be situated (Figure 1.3).
- *Elevation.* An elevation drawing shows one face of the building perfectly to scale, often 1:100 (Figure 1.4). An elevation is drawn for each side of the building, and can be coloured to approximate the colours of the materials to be used.

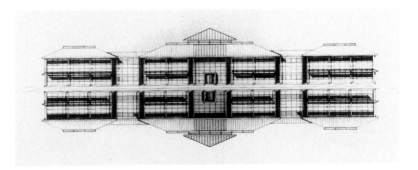

Figure 1.4 An elevation drawing. Again, a preliminary elevation drawing showing the front face of the NETC building. The mirrored image suggests its reflection in the surrounding water

- *Section.* A section drawing is a vertical plane cut through a building to show room heights, the position of staircases, depth of foundations etc.
- *Perspective.* A perspective drawing of a building is simply a visual impression of how the completed building is likely to look (Figure 1.5). It is not an accurate drawing for purposes of measurement, and therefore allows the possibility of a degree of distortion.
- *Isometric projection.* An isometric projection is a geometrical drawing to show a building in three dimensions (Figure 1.6). The angles of the building are set at 30° to the horizontal, with the internal corner at 120°,

Figure 1.5 A preliminary perspective drawing of the NETC building to give a visual impression of how the completed building was likely to look

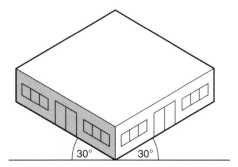

Figure 1.6 An isometric projection, with angles of the building set at 30° to the horizontal, and verticals remaining vertical

and the verticals remaining vertical. Such a projection gives the illusion of perspective, but with all vertical and horizontal dimensions of the building accurately scaled.

● *Axonometric projection.* An axonometric projection is also a geometrical drawing to show a building in three dimensions (Figure 1.7). However, in this type of projection, the plan retains its true angles and dimensions, but is set at a convenient angle (typically 60° and 30°, or 45° and 45°) with verticals drawn vertically to scale. Horizontal dimensions are also to scale, but diagonals and curves on a vertical plane are distorted. The effect of an axonometric projection over an

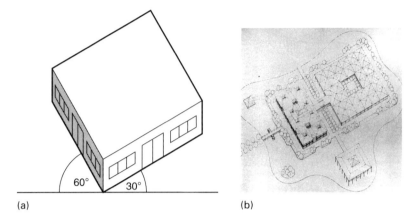

Figure 1.7 An axonometric projection, to give more of a bird's eye view of the proposed building. Drawing (b) shows its practical application in the NETC project

(a) (b)

isometric projection is to give more of a bird's eye view of the proposed building.
- *Working drawings*. Working drawings are those specifically drawn up for the builders, plumbers, electricians etc. with accurate details for their particular jobs.

Proportion

Proportion is a harmonic, mathematical relationship of the relative size or arrangement of two or more elements in a composition. Architecturally speaking, it is the ratio of different parts of a building to the whole. Classical and Gothic architecture, with all its detail, was built with great attention to harmonious proportion.

A proportion that has been used throughout history since the time of the ancient Greeks is known as the 'Golden Section'. It is defined as to cut a finite line in such a way that the smaller section is to the greater as the greater is to the whole (see Figure 1.8). The resulting section is roughly in the proportion 5 to 8, 8 to 13, 13 to 21 etc. (or 1:1.618), but never exactly so, causing it to be known in mathematics as an irrational proportion. It was thought to be divine by the Renaissance theorists, who called it the 'Divine Proportion', and applied it extensively in their buildings. Leonardo da Vinci demonstrated that it was the essence of universal harmony and beauty. It is to be found throughout nature – the male nude is divided by the navel in this proportion; as is, for example, the cross section of a nautilus shell – which suggests we instinctively empathize with it. In both art and photography, the proportion is frequently used for the relation of the area of sky to that of the land, or of the foreground to the background, roughly approximating the Law of Thirds discussed in Chapter 5.

Other proportions have been developed and successfully employed by architects, notably the 'modulor' system developed by Le Corbusier in which he placed two series of proportional numbers against each other to produce a whole range of dimensions that would be harmoniously related to each other.

We seem to be intuitively aware of when a building appears 'out of proportion', which suggests that our natural expectation for the environment, and the buildings that form a large part of it, is towards an ordered harmony.

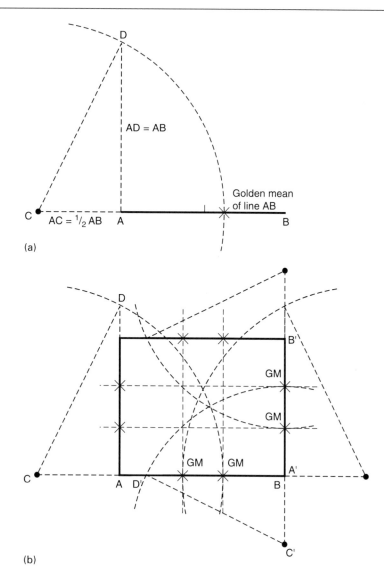

Figure 1.8 'The Golden Section'. Drawing (a) shows how to find the golden mean of a line; while drawing (b) shows how a rectangle can be divided up by following this principle. Applying this to photographic composition, note how these divisions are similar to those of the simpler Law of Thirds illustrated in Figure 5.3 in Chapter 5

Scale

Scale is a comparison of relative size. With architecture, this size can be relative to either ourselves or to other buildings, and can be illustrated photographically by including people in the shots.

People like to be able to relate to buildings on a human scale. In confined urban areas, people can only relate to very tall buildings at a distance. Anyone who has visited the Empire State Building in New York, for example, will tell you that one is completely unaware of its massive presence when one is standing directly outside its front entrance. In fact, unless following a map closely, it comes as a sudden surprise to see the words 'Empire State Building' written above its entrance as one walks down the street.

People find it much easier to relate to lower-level buildings that they can view as a whole from within the immediate vicinity. Taller buildings demand wide open spaces around them to afford a similar relationship.

A variation in the height of buildings in a city adds to its visual interest and contrast, though in terms of scale, people do not like to see the older buildings (considered to be on a more human scale) dwarfed by modern high-rise developments.

Perspective

'Perspective' is defined in the dictionary as 'the art or system of representing three-dimensional objects in spatial recession on a plane surface'. In other words, perspective is the effect of things getting smaller as they recede into the distance.

So perspective does not exist inherently in a building, but in the way the eye sees it and according to the angle of viewpoint the observer or photographer has chosen. Viewed at an angle, the parallel horizontal lines of a building appear to converge, causing the vertical lines of equal height to appear as if they are getting progressively shorter.

Architects can successfully exploit the effect of perspective for visual impact. This was a popular technique used in Renaissance architecture with its great colonnades.

Aesthetics of architecture

All of us initially witness architecture in purely visual terms. For those of us who have no need or desire to enter a particular building, it usually remains a visual experience, though our lives may be affected to some degree by its physical presence. That experience can stimulate us, or bore us, but we cannot escape it.

It is the responsibility of the architect, therefore, to create visually satisfying buildings that transcend the merely practical purposes for which they are built. The architect must synthesize the practical objectives with his visual intentions to achieve an integrated whole, or unity. If he fails to achieve his visual objectives, some would argue that the result would be a serviceable building, but would not merit the term 'architecture'.

In his book *Principles of Design in Architecture*, K.W. Smithies identifies three principles of design that relate to visual objectives:

1 The visual composition, that is the syntactical relationship of part to part and each part to the whole in visual terms.
2 The semantics, that is the effect of a design on the mind of the observer, or expressiveness.
3 The wider relationship between design and setting in place and time, also its direct relationship to human size – magnitude.

The outline in this chapter of the fundamentals of architecture aims to provide an awareness of the architect's approach to design; some useful background knowledge; and an understanding of the terminology of architectural drawing that a photographer specializing in this area is likely to encounter. In the next chapter, we turn our attention to the specialist equipment needed to satisfy the critical demands of architectural photography.

2
Specialist cameras and lenses

Introduction

In a world of ever-increasing efficiency, manufacturers periodically strive to produce a single camera that can satisfy the requirements of all photographic demands . . . an 'ultimate' camera that does all things for all photographers. However, such a dream is unlikely to be realized due to the often contradictory demands that would be made of it. As a result, some unwieldy camera monsters have been produced that manage a gesture of most facilities without the full advantage of any.

Photography is divided into specialist branches, and therefore the most appropriate equipment to use is that designed specifically for your particular area of specialization.

As I have already mentioned, and shall continue to do so throughout this book, the paramount requirement of a camera for architectural photography is the ability to reproduce the straight lines of a building with absolute precision and true verticality. This can only be achieved consistently through the use of a 'view camera' which is able to overcome the potential problem of converging verticals in an image through the use of its extensive 'camera movements' (see section on 'The need for camera movements' later in this chapter).

While medium format SLR cameras do have their place within the realm of architectural photography, as we shall see shortly, our primary concern must be with the view camera, the mainstay of any serious architectural photographer's equipment.

View cameras

View cameras have the simplest basic construction of any professional camera, consisting of a rail on which is mounted a front standard to hold the lens panel, and a rear standard to hold the focusing screen or film holder, with a set of flexible bellows in between (Figure 2.1). It is the precise engineering of the mechanics, the technical perfection of the lenses, and their limited demand that make such simple cameras expensive pieces of equipment.

The virtue of such a simple design is that it enables the possibility of extensive camera movements to achieve a variety of useful optical effects otherwise impossible, or at most limited, with any other type of camera.

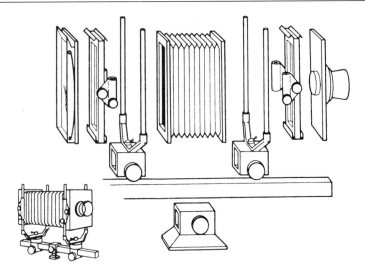

Figure 2.1 The basic elements of construction of a monorail view camera. The simple design enables the possibility of extensive camera movements to achieve a variety of useful optical effects

The disadvantage of this basic structure is that the subject has to be viewed as an inverted and reversed image on a ground-glass screen, which itself can only be viewed in darkness under a black cloth. Initially this can seem inconvenient, denying the photographer the opportunity of spontaneous changes of camera position to evaluate the best viewpoint. However, with experience, the photographer develops a contemplative patience and an awareness for likely suitable camera positions.

Two devices are available to assist with these problems. Firstly, it is possible for the image to be partially corrected in orientation using a reflex prism finder (which also does away with the black cloth and magnifier necessary for critical focusing), but it does further reduce the light level of the image on the focusing screen which can be very weak, especially when photographing interiors. Secondly, to assist your assessment of the best camera position, it is possible to use an independent optical viewfinder matched to the focal lengths of your lenses, enabling you to move freely around whilst seeing how this affects the subject image.

Finally, a valuable addition is a fresnel lens mounted in front of the ground-glass focusing screen. This is a piece of clear plastic with a pattern of concentric circles cut into its surface that redirect the light rays passing through the edges of the screen at an angle, back towards the viewer. This effectively brightens the overall image, making viewing and focusing significantly easier, especially in low light conditions.

View cameras are available in a variety of formats, from medium (6 × 7 cm or 6 × 9 cm) to large (typically 5 × 4 in. or 10 × 8 in.).

Medium and large formats

Both medium and large formats yield extremely high quality photographs for purposes of reproduction. Of course, the larger the format, the higher the quality of the photographic image due to the smaller amount of magnification needed for reproduction. In fact, a 10 × 8 in. camera produces images that can often be contact printed, not enlarged. This renders exceptional sharpness and a very rich tonal scale. With a film

area four times larger than the 5×4 in. format, 10×8 in. transparencies have unmatched richness and depth. However, unless billboard proportions are a regular requirement, the extra quality is often unwarranted.

The most popular format for architectural work is the 5×4 in. with its large format image quality and also the flexibility to take a roll film back when using the appropriate adaptor. Personally, I favour the medium format view camera as it is inevitably smaller, lighter and therefore more portable than its larger format equivalent. This is a sensible practical consideration for architectural work as you will at times have to carry your equipment considerable distances. The roll film back also enables wider experimentation and bracketing for each shot, with ten frames per roll.

Large formats use single sheets of film which, when using several to allow for processing adjustments, spares or potential damage, adds significantly to material costs over their medium format equivalents.

As well as there being a choice of formats, there are also two basic types of view-camera design available: the monorail, and the highly portable folding baseboard camera.

Monorail cameras

Monorail cameras, as the name suggests, consist of a single metal rail on which are mounted the lens standard and the film standard. The mounting blocks for the lens and film standards can each be slid along the calibrated track for purposes of focusing. The standards themselves can be shifted up and down and/or sideways, or tilted or swung to achieve the desired optical effects for specific situations, as outlined later in this chapter. The potential extent of these camera movements is considerably greater than those on its baseboard camera equivalent, with adjustments physically freer and less restricted.

Baseboard cameras

The strength of the baseboard camera is its ability to fold away into a compact box, making even the larger formats highly portable and swift to erect (Figure 2.2). The front of the box is opened on a hinge, and the lens standard pulled out onto the previously folded runners. The runners are then moved backwards or forwards with a knob to focus the image. Some medium format models have a built-in rangefinder allowing the camera to be focused handheld. However, for the purposes of architectural photography, the advantage of portability is outweighed by the disadvantage of restricted camera movements. Any serious architectural photographer would choose a monorail for its smoother basic operation and more extensive movements.

The wood and brass variety of baseboard camera, known as 'field cameras', are beautiful instruments that conjure up a romantic illusion of the bygone days of pictorial photography. They are, however, better suited to high quality travel work than to the precise optical demands of architectural photography.

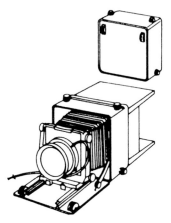

Figure 2.2 The baseboard camera is a type of view camera that can be conveniently folded away into a compact box, making it very portable. However, for purposes of architectural photography, the advantage of portability is largely outweighed by the disadvantage of restricted camera movements

The need for camera movements

Most cameras, and notably the SLR (Single Lens Reflex), are designed with the film mounted parallel with the lens, and rigidly centred on its axis. This produces the most optically accurate representation of the subject, with true scale of reproduction as long as the film plane remains parallel to the subject plane.

However, in order to take in the full height of a building, for example, the whole camera has to be tilted. This has the effect of tilting the film plane out of parallel with the front of the building, varying the scale of reproduction across the subject image. In other words, the verticals in the image start to converge, with the visual result being that the building either appears to be falling over backwards if photographed straight on, or falling in on itself if photographed from an angle.

For the verticals in the image of a building not to converge, the film plane must be kept perfectly vertical. There are three alternative ways of achieving this, to include the full height of the elevation of the building.

Firstly, you could raise the height of the camera to half the height of the building being photographed. Unless there is an accessible building directly opposite of sufficient height, or you can provide a hydraulic platform truck, this is an impractical alternative.

The second possibility is to keep the camera back (i.e. the film plane) vertical, but use a lens of wider angle to include the full height of the building. However, such a lens will also include an excessive amount of foreground when the camera is kept vertical, and this would have to be cropped out at the printing or reproduction stage. Consequently, this effectively reduces the format size, and therefore image quality, demanding greater magnification for purposes of reproduction. The other disadvantage of this alternative is that it forces the photographer to use a lens of wider angle than he would otherwise have chosen, with the likely result of a more exaggerated perspective than necessary.

The final option is to move the lens vertically in relation to the film, i.e. a shift movement. This is the most important of all available camera movements in architectural photography. It will be explored in detail in the following section.

The camera movements available on a view camera can be divided into two main categories: shift movements which are parallel movements of the front and/or rear standard in a vertical or horizontal direction; and Scheimpflug adjustments which are swing or tilt movements of either standard.

Rising shifts

Shift movements in the vertical plane are known as 'rising' or 'drop' shifts, and it is these that comprise the all-important view camera facility that architectural photographers use to eliminate the problems of converging verticals in exterior work, and diverging verticals in interior work (Figure 2.3). The lens panel remains parallel to the focusing screen/film plane and is shifted either up or down from its neutral, central position.

Shifting the lens up (rising front) therefore overcomes the problem of having to tilt the camera to include the full height of a building. Shifting the lens down (drop front) enables verticals to be retained in interiors without

(a)

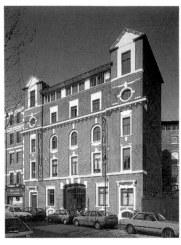
(b)

Figure 2.3 Photograph (a) demonstrates the convergence of the verticals in the image of the building as a result of tilting the camera to include its full height. Such an image is typical of an SLR or other fixed plane camera. Photograph (b) shows how the verticals can be corrected for purposes of architectural photography, by using a simple rising-front shift movement on a view camera

including too much ceiling at the expense of foreground, or having to photograph from an unnaturally low position.

True verticals and horizontals are confirmed on a view camera by the camera's integral spirit levels. The levels will guarantee the perfection of the lines so demanded by architects, and avoid any possibility of convergent verticals which would jar visually with the perfect verticals of both the photograph edge and the printed page.

Cross shifts

Figure 2.4 The shift movements available on a view camera are parallel movements of the front and/or rear standards. Rising shifts are shifts in the vertical plane, and cross shifts are shifts in the horizontal plane

Shift movements in the horizontal plane are known as 'cross shifts' (Figure 2.4). They can be used to take an apparently straight-on view of a building whilst actually standing to one side of it, which is sometimes necessary when the viewpoint is restricted. The camera is lined up parallel with the front elevation, even though not central to it, and a cross shift is employed rather than turning the camera on the tripod. This prevents any perspective 'distortion' and maintains the perfect horizontal lines of the building to give the impression of a straight-on view.

The most frequent use of cross shifts in exterior architectural work is to control perspective. When photographing a building at an angle from a relatively close vantage point with a wide-angle lens, the perspective of the receding building is exaggerated. To partially offset this, the camera can be turned on the tripod to make the angle to the building less acute. A simple cross shift of the lens will then bring the whole building back into view with a somewhat flattened perspective, thereby expanding the area of the front elevation that is visible through the lens. Figure 2.5 demonstrates this effect, by photographing the building from the same position both with and without cross shift.

Cross shifts can also be used to create an accurate panorama. A montage can be made with a series of shots taken with shifts from the extreme left to the extreme right, avoiding the problem of semicircular horizontal distortions that would arise if the camera was swung to the left and right instead.

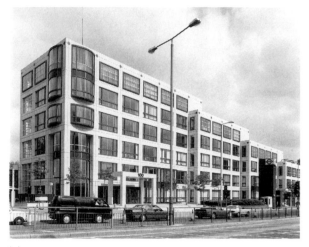

(a)

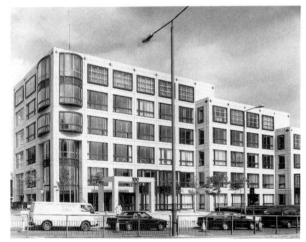

Figure 2.5 Cross shift
movements for perspective
control from a restricted
viewpoint. Image (a) was taken
without any cross shift, while
image (b) was taken with the
same lens from exactly the
same place, but with the camera
turned on the tripod for a flatter
perspective on the elevation. A
simple cross shift movement
was used to re-centre the image.

(b)

For interior work, cross shifts can be employed to prevent the parallel horizontal lines of floor and ceiling from converging as a result of perspective 'distortion' when photographed from an angle. The camera can instead be placed in parallel with the far wall, and the lens shifted horizontally to include more of the room and less of the side wall whilst retaining perfect horizontals – see section on 'Correction of horizontal convergence in interiors and exteriors' in Chapter 9.

Such cross shifts for interiors should be used cautiously as horizontal perspective 'distortions' are naturally expected and are therefore more visually acceptable than vertical 'distortions'.

It is the same cross shift technique that is sometimes used in interior photographs to apparently photograph a mirror head-on without the reflection of the camera appearing in it.

Within the limitations of the lens (see section in this chapter on 'Lens coverage') you can use a combination of both rising and cross shifts of either front or rear standard to achieve desired results.

Problems of excessive shift

Apart from the limitation of the lens in terms of covering power – the extremes of the image circle produced by the lens – another problem can arise when using an excessive shift movement to photograph a tall building.

This is a problem of geometrical distortion whereby the outermost part of the field of view actually becomes elongated resulting in a building appearing top-heavy: see Figure 2.6. Although the verticals are actually parallel, the optical illusion is that they appear to be diverging slightly.

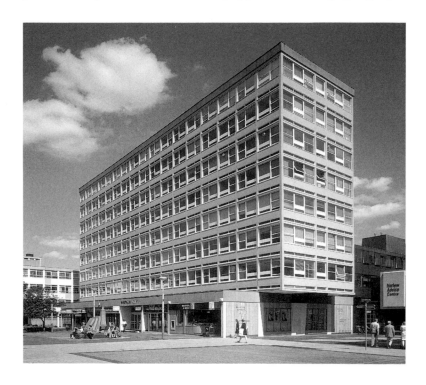

Figure 2.6 Excessive shift movements used to retain the verticals in the images of tall buildings can cause geometrical distortion as illustrated here, whereby the building appears top-heavy and the verticals, though parallel, appear to be diverging slightly

One way to overcome this is to reduce the amount of shift being used. With a tall building this is most effectively achieved by raising the camera position to approximately one third the height of the building, probably by working from just such a height in a nearby building. If this is not possible, you could use a lens of shorter focal length (i.e. of wider angle), select a more distant vantage point, or even tilt the camera slightly — see section on 'Tall buildings' in Chapter 8 for further details.

Scheimpflug adjustments

The adjustments made in accordance with the Scheimpflug Principle are the swing or tilt movements of either standard. Swing movements are swings around the vertical axis; tilt movements are tilts over the horizontal axis (Figure 2.7). Swinging or tilting the lens alters the plane of focus without changing the shape or position of the image, thereby controlling the depth of field.

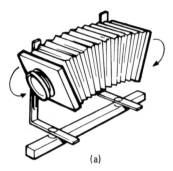

(a)

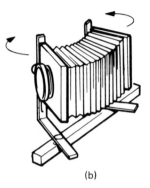

(b)

Figure 2.7 The Scheimpflug adjustments available on a view camera are the swing and tilt movements. The lens panel or focusing screen, or both, are either swung around a vertical axis (a) or tilted over a horizontal axis (b). This alters the plane of focus, and can thereby increase the depth of field along one plane

The limitation of Scheimpflug adjustments is that they can only control depth of field across one specific plane of focus. This restricts their use in architectural photography where the subject matter is usually three-dimensional.

They can, however, be useful for detail shots of elevations photographed at an oblique angle. Using a camera without the facility of movements can make sharp focus across the full depth of the plane impossible, even with the lens fully stopped down. Focusing in the middle of the elevation is likely to leave both near and distant parts of the elevation out of focus.

The swing movements possible on a view camera enable sharp focus to be achieved across the full depth of the elevation by altering the plane of focus. The Scheimpflug Principle states that if you swing the lens around the vertical axis a few degrees so that the subject plane, the focal plane (i.e. the focusing screen/film back plane), and the lens panel plane all intersect at an imaginary common line, you will maximize the depth of field along the subject plane (see Figure 2.8).

According to the Scheimpflug Principle, it theoretically makes no difference whether the front or rear standards, or a combination of the two are adjusted, so long as the three planes intersect at a common line.

Practically speaking, however, it does make a difference. Swinging the lens panel is limited by the covering power of the lens, and any movement of the camera back alters the perspective to a degree, especially of the foreground subjects.

If maintaining the perspective is of paramount importance, then swinging the lens panel alone is the best way to increase depth of field. If precise perspective is not an issue, the way to achieve maximum depth of field along the oblique subject plane with maximum lens coverage and minimum lens distortion is to swing both the front and rear standards around the vertical axis equally, but in opposite directions, with the three planes still intersecting at an imaginary common line.

Tilts work in precisely the same way as swings, except around a horizontal axis, as the name suggests. They are used to increase the depth of field along the ground, enabling subjects to be sharply focused from extreme foreground to infinity, at relatively wide apertures. Subject height above ground level, however, is unlikely to be sharp unless the lens is well stopped down in the usual way.

Generally speaking, for architectural work it is best to stop down the lens (i.e. reduce the size of the aperture) to achieve maximum depth of field in the three dimensions. If this is not enough, you will have to use a lens of wider angle to create a smaller reproduction ratio (the smaller an object is reproduced on film, the greater the depth of field around it).

Figure 2.8 The Scheimpflug Principle for maximizing depth of field. The film plane, lens plane and subject plane must all intersect at an imaginary common line, with an equal swing on both the front and rear standards

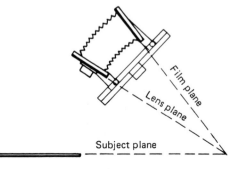

Subject plane

Single lens reflex cameras

Single lens reflex cameras (SLRs) are the most common type of medium format and 35 mm camera (with the possible exception of direct viewfinder cameras, or 'compacts' as some are known, which are largely confined to the amateur market). A hinged 45° mirror reflects the inverted image up to a horizontal focusing screen, which is then corrected by the pentaprism in the viewfinder. The mirror flips up, out of the way, a split second before the shutter is released. Because the distances between the lens and focusing screen, and between the lens and film is the same, the image that is sharply focused on the screen will be sharply focused on film. In other words, the image you see through the viewfinder is the actual image that will be recorded on film, though helpfully corrected from its original inverted state.

The SLR is rarely useful for full elevation shots due to its lack of essential camera movements. It is, however, a necessary complement to the view camera for architectural photography, especially for detail shots, abstracts and moving subjects.

The basic strengths of the SLR are that it is quick and simple to use, and enables the photographer to view the subject image right up to the moment of exposure. For example, when people are integral to a particular shot of a building, you can watch them through the viewfinder, releasing the shutter at the precise moment of perfect configuration of all the elements of the composition, whatever the perspective produced by lenses of different focal lengths. This is impossible on a view camera, and precise composition of a moving subject can only be guessed at by viewing the subject with the naked eye at the moment of exposure, unless carefully rehearsed beforehand.

The most frequent use of the SLR in architectural photography is for detail shots and abstracts. The versatility of the SLR allows the photographer to spontaneously 'snap around' at important features of a building. For abstract work, dramatic angles and unusual composition can be instantly viewed, modified and adjusted, whilst walking around if necessary in search of the perfect viewpoint. Such shots can be both difficult to find and laborious with a view camera.

The ability to view the image until the moment of exposure, permits the photographer to use the SLR handheld in awkward situations. With a fast shutter speed and/or the photographer's elbows supported, this is possible on medium format cameras as well as 35 mm. The handheld facility is particularly useful when taking photographs from partially open windows, or from ground level for dramatic shots.

For the high quality results expected from architectural photographers, the medium format of 6 × 7 cm or 6 × 6 cm is preferable to 35 mm. It is also more practical as it allows the photographer to interchange the film back with an instant-print magazine back in order to check the results prior to shooting the actual film.

Shift lenses

Shift lenses, also known as 'perspective control' lenses, are designed for SLR cameras to give them a limited amount of the shift movements available on a view camera.

Such lenses are useful if choosing to work exclusively with an SLR, as it does enable the verticals of buildings to be accurately reproduced without convergence in many situations. However, they tend to be very expensive, are limited in the amount of shift possible, and perhaps most importantly, are often restricted to a single focal length (typically a medium wide-angle: 75 mm for medium format or 35 mm for 35 mm format). With the view camera, the movements are integral to the camera body (thereby allowing movements with lenses of all focal lengths), whereas the movements of an SLR shift lens are integral only to the individual lens on an otherwise rigid camera body.

Choice of lenses

A practical complement of lenses should span from very wide angle to modest long focus.

Because wide-angle lenses are so frequently used for architectural photography (both for their dynamic impact and their ability to overcome the problem of working in confined areas), it is sensible to have at least two such lenses: a very wide angle (47 mm on medium format) and a medium wide angle (65 mm on medium format). A third wide-angle lens (75 mm on medium format) between the medium wide angle and the standard lens (100 mm on medium format) would also prove useful for exterior work, if affordable.

The standard lens, being the approximate equivalent to the focal length of the naked eye, is an obvious essential for 'normal' perspective in architectural shots (Table 2.1).

A modest long-focus lens (180 mm on medium format) for more distant shots is useful for showing the context of a building within a land- or cityscape, by apparently compressing the planes of the image. It also enables a building to be selectively isolated from its landscape. In contrast to the enhanced perspective of an image taken with a wide-angle lens

Table 2.1 The angles of view of different lenses for different formats. Comparisons cannot be exact due to the different proportions of the film formats, but they do provide a useful guide for purposes of cross-reference

		Format			Approximate angle of view
	35 mm	6 × 7 cm	5 × 4 in	10 × 8 in	
Wide-angle				125 mm	92°
	20 mm	47 mm	65 mm		84°
	24 mm	58 mm	75 mm	165 mm	79°
	28 mm	65 mm	90 mm	180 mm	68°
			105 mm	210 mm	62°
	35 mm	75 mm	125 mm	250 mm	55°
Standard or normal			135 mm		51°
	50 mm	90 mm	150 mm	300 mm	44°
		100 mm	180 mm	375 mm	38°
Long-focus		135 mm	210 mm	450 mm	35°
	85 mm	150 mm	240 mm	480 mm	29°
	105 mm	210 mm	300 mm	600 mm	22°
			375 mm	750 mm	18°
	135 mm	250 mm	450 mm		15°

(Focal length)

(which produces dynamic, angled lines) the long-focus lens flattens perspective with a tendency toward horizontal and vertical lines. It is probably sensible to hire longer focus lenses on the few occasions that they are required.

With three or four basic lenses, you will be able to deal with most demands made of you as an architectural photographer. Of course, the larger your collection of lenses, the more flexible your choice of viewpoint, and therefore the greater the number of possibilities open to you. Quality, however, is much more important than quantity with a restricted budget.

Wide-angle lenses

Wide-angle lenses deserve special attention because of their unusual attributes and extensive use in architectural work.

The main positive quality of wide-angle lenses for architectural photography is that they enable full elevations (and wide coverage of interiors) to be photographed from relatively close viewpoints. This overcomes the problem, especially in towns and cities, of restricted space, and has the further effect of isolating a particular building from the clutter of its surroundings.

However, while this often produces pleasing, dramatic shots with exaggerated emphasis on the specific building being photographed, such distortion represents an impossible image to the naked eye of an observer standing in the same position due to the wider angle of view that it is able to encompass. The perspective produced by a wide-angle lens causes any wall not exactly parallel with the camera back to recede sharply into the distance. This becomes more obvious the closer in angle one gets to the corner of the building (Figure 2.9).

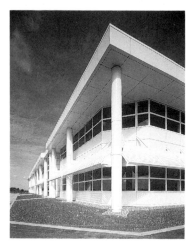

Figure 2.9 The use of a wide-angle lens from a close viewpoint produces a dramatic shot with exaggerated perspective, and accordingly, exciting line dynamics (NETC building)

Depending upon the use for which the photographs are being taken, the photographer should retain an awareness of these perspective distortions and use such lenses judiciously. Excepting the specific requirement for a natural human perspective in a shot (which can only be achieved with a

standard lens) wide-angle lenses add an exciting impact to the image of a building from their tendency to produce diagonals and therefore dynamic tensions (see section on 'Line dynamics' in Chapter 5). As a consequence, their results are popular in advertising brochures. They also have the further advantage of an increased depth of field over lenses of longer focal length. The wider the angle of a lens, the smaller an object is reproduced on film, and therefore the greater the depth of field around it.

Lens coverage

All lenses produce an image over a circular area, called the 'circle of illumination' (Figure 2.10). Within this circle of illumination sits the slightly smaller 'circle of good definition', in which the image is sharp for normal photography. The diameter of the circle of good definition is known as the covering power of the lens, and this increases as lens aperture is reduced or the lens is focused closer.

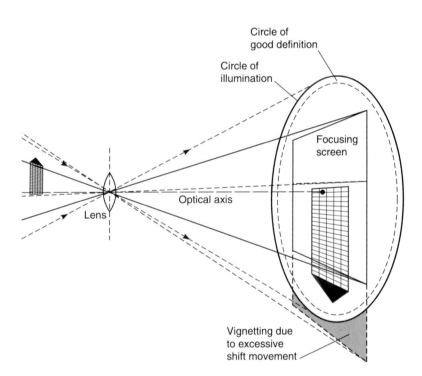

Figure 2.10 The parameters of the focusing screen on a view camera must fall well within the circle of illumination produced by a lens to enable a limited amount of camera movements. This drawing illustrates the problem of 'vignetting' in an image caused as a result of an excessive shift movement

The covering power of regular lenses designed for SLR cameras is only a little wider than the image area viewed. This is fine for such cameras as the film plane is permanently centred on the fixed axis of the lens.

However, with both shift lenses and view camera lenses the covering power has to be much wider to take account of any shift, swing and tilt movements that can be used. The film area has to remain within the covering power of the lens when movements are used, or else the corners of the image will blur into a dark vignette as the edge of the circle of illumination is reached. Any doubts over whether the camera movements

Figure 2.11 An example of the dark vignette at the top of the image caused by an excessive rising front shift movement. This movement was necessary in order to photograph the whole building from a restricted viewpoint while retaining perfect verticals in the image

employed fall within the covering power of the lens can be easily checked using instant-print film (Figure 2.11).

Good lenses for view cameras are designed to allow generous covering power. The best choice for extreme movements is a wide-angle design normally intended for a larger format image. For example, a 210 mm wide-angle lens for a 10×8 in. format can be used with a 5×4 in. format to give a slightly long-focus lens with very wide covering power.

Lens aperture, speed and performance

It is useful to have a basic understanding of the technical criteria involved when making your personal selection of lenses.

The maximum aperture, or f-number, of a lens is always quoted along side the focal length of the lens, for example, 100 mm f5.6. This is because for action photography, the larger the aperture, the faster the shutter speed that it is possible to use. This has the advantage of either allowing the photographer to work with a reasonable shutter speed in low light conditions; or to use a slower, finer grained film for optimum image quality.

For the purpose of architectural photography, such use of fast shutter speeds on a lens is rarely a priority as the view camera is mounted on a tripod with the subject completely static more often than not.

A 'fast' lens, i.e. one with a wide maximum aperture, can be useful for architectural work. The wider the aperture, the brighter the image appears on the ground glass focusing screen. This can be especially helpful when photographing interiors where light levels are typically much lower than outside, and also for critical focusing on exterior dusk shots.

The f-number of a lens, indicating the maximum aperture, is calculated by dividing the lens-to-film distance when the lens is focused at infinity (the focal length of the lens) by the effective diameter of the aperture, or lens opening. A lens with, for example, an f/5.6 maximum aperture can cost more than twice as much as one of identical focal length with an f/8 maximum aperture. This may seem unreasonable, but in order to double the quantity of light passing through the lens, the performance of that lens has to be substantially improved to take account of the wider aperture. This is

because the worst aberrations, or optical errors, of a lens tend to occur towards the outer limits of the lens image field.

Optimum lens performance is achieved at an aperture somewhere between the maximum and minimum apertures available, and often around the middle of the *f*-number range. This is because progressively stopping down the lens from its maximum aperture reduces any residual aberrations but increases the effects of diffraction. Diffraction is a natural phenomenon that causes part of a light beam to deviate from its path when it passes close to the edge of an opaque obstacle, or in this case, when it passes through a narrow aperture. Its effect is to impair the lens's ability to resolve fine detail.

Practical lens testing

All lenses used for professional photographic work are compound lenses: a combination of several different lens elements within a single lens barrel. This is because the image quality produced by a single lens element alone is quite inadequate for photographic purposes. Straight lines (which are obviously critical in any interior or architectural work) become curved, and if the image is sharply focused at the centre of the focal plane, the edges will be blurred. Only by combining several lens elements in a symmetical configuration can these aberrations best be corrected.

While most medium and large format lenses are of a high standard, and the best of a very high standard, they should still be critically tested for the specific purpose for which they are to be used. In the case of architectural photography, with its emphasis on perfectly straight lines, the lenses should be tested for curvilinear distortion, i.e. the curving of straight lines towards the edges of the image. On the printed page, any curving of supposedly straight vertical or horizontal lines, especially at the edges of the image, becomes very apparent beside the perfectly squared edges of the picture on the page.

There are two types of curvilinear distortion: 'barrel distortion' and 'pincushion distortion' (see Figure 2.12), both caused by uneven magnification in the lens. Wide-angle lenses are prone to barrel distortion, especially at focal lengths approaching those of a fish-eye lens where such distortion is permissible; and long-focus lenses are prone to 'pincushion distortion'. It is barrel distortion of wide-angle lenses that is our greatest concern in architectural photography, and for which we need to test our lenses as critically as possible.

A practical test is to photograph a perfectly straight line – either the clean edges of a modern building, or a modern door frame are suitable subjects – at the outer limits of the image area: top, bottom and sides. When the film is processed, use a manufactured black card transparency mounting mask, with its perfect right-angles, to analyse the results on a lightbox. Place the edge of the mask very close to the edge of the subject and visually compare the two for any bowing of the straight lines in the image beside the straight edges of the mask. These should be apparent to the naked eye on medium and large formats. If any barrel distortion is evident, you will have to reject the lens in favour of a better one. A similar test can be devised to test for pincushion distortion on long-focus lenses of telephoto configuration.

While modern lenses are well corrected for most aberrations, there are several other potential lens defects that deserve at least brief attention. With

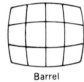

Barrel

Pincushion

Figure 2.12 The two types of curvilinear distortion caused by uneven magnification in the lens: 'barrel' and 'pincushion' distortion

the exception of transverse chromatic aberration, these other aberrations can all be improved by stopping down the lens. This is unlike curvilinear distortion for which stopping down the lens makes no improvement, and contrary to the problem of diffraction which worsens the more the lens is stopped down. Other potential lens defects include the following:

1 Axial chromatic aberration, which is the failure of a lens to focus at least two out of the three primary colours to the same point on the film plane, causing colour fringing.
2 Transverse chromatic aberration, which produces images of different sizes for the different colours of off-axis rays, again causing colour fringing. This problem is most likely to occur with telephoto lenses.
3 Spherical aberration, which is the failure of a lens to focus the rays of light passing through the centre and the edge of that lens to the same point, causing a blurring of detail across the whole image.
4 Coma, which causes point sources of light to appear as smeared comma shapes on film. It affects the image progressively less towards the centre, so with dusk shots, for example, try to keep bright street lamps away from the corners of the frame if your lens suffers from this problem.
5 Curvature of field, which is the failure of a lens to focus its image onto a flat plane, so if you focus on the centre of the image, the corners will not be sharp, and vice versa.
6 Astigmatism, which causes a lens to form a linear image from a point source of light, with the line changing from vertical to horizontal as the lens is focused. The effect of any residual astigmatism in a lens is its inability to focus equally horizontal and vertical lines, with the possible result that vertical lines in the subject may appear sharper than the horizontal ones.

A practical method for testing a lens for most of the above potential defects (excluding coma which can only be successfully tested for by experimentation with point sources of light in night or dusk shots) is to photograph the exterior of a modern building that has regularly repeated architectural details. From such a test you should be able to visually assess the lens's ability to resolve details across the whole image area.

Every manufacturer sets its own minimum image quality acceptance standards. Higher prices often mean stricter quality control, so for the critical demands of architectural photography on the performance of a lens, it is sensible not to economise.

3

Ancillary equipment and film

Introduction

The specialist camera and lenses that you have chosen now need to be backed up by the appropriate ancillary equipment necessary for architectural work. This will include lighting equipment, various meters for light measurements, and a robust tripod, along with the more mundane but equally important extras such as cables and spare batteries.

Finally, film choice must also be considered in order to determine the most suitable film types for the kind of work in which you will be specializing.

Lighting equipment

Artificial lighting is infrequently used for exterior architectural work, but is essential for most interior photography. Photographic lighting can broadly be divided into two main categories: flash and tungsten. Flash is the best choice to simulate natural white daylight in terms of colour temperature. In an interior, where daylight is dominant, flash is the perfect 'fill-in' light for the most natural appearance on film – see Chapter 6. Bouncing flash off a white umbrella or white wall produces a natural and unobtrusive supplementary light source (Figure 3.1). Tungsten light can also be used as a 'fill-in' light source, either filtered to approximate photographic daylight, or unfiltered in the rare situations of exclusively tungsten available light. However, its most effective use in interior photography is for dramatic sunshine effect lighting, which is not a regular practice of the architectural photographer. I shall therefore restrict this section on lighting equipment to flash lighting alone, the ideal light source for interior architectural work.

Flash lighting comes in various forms: from a simple on-camera flashgun, through integral mains units, to flash heads powered by a studio power pack. Portability is an important factor in the choice of lighting equipment, since all architectural work is, by definition, location work.

While a portable flashgun is useful to brighten some exterior detail shots, its output is generally too low for successfully lighting interiors. It can, however, be used in conjunction with larger units to illuminate dark corners or spaces while actually hidden within the picture area itself. A

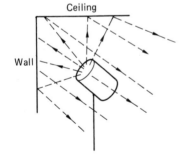

Ceiling

Wall

Figure 3.1 Bounced flash off a white umbrella, or off the apex of a white wall with the ceiling, is an unobtrusive source of 'fill-in' light to supplement daylight in an interior

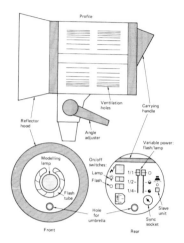

Figure 3.2 The integral flash unit: the profile, front view, and rear view showing the controls

'slave unit' (a flash-sensitive triggering device) attached to it will fire the flashgun the instant it receives light from another flash source.

In terms of portability, a studio power pack with flash heads is impractical. The pack is large, heavy and unwieldy and necessitates extra, sometimes obtrusive, cabling. The most popular choice is a set of integral mains flash units which, although individually heavier as heads, are much more portable and simpler to use. The power of these units ranges from the weakest at around 200 Joules to the most powerful (and accordingly the heaviest) at around 800 Joules. Units with a variable power up to 500 Joules give a convenient output for lighting interiors. In small interiors, one or two heads are often sufficient, though it is sensible to carry at least three to enable you to cope with most situations.

The integral flash unit consists of a circular flash tube surrounding a modelling lamp (for previewing the effect of the light) at one end of the housing, with controls at the opposite end (Figure 3.2). The controls usually consist of a mains supply switch, two knobs for varying the output of the flash and modelling lamp, and a 'slave unit' for triggering the unit when used in conjunction with one or more other units. Apart from having a synchronization cable from one of the units connected to the camera, every other unit only has to be connected to a regular 13A socket. The flash-sensitive slave units trigger their firing as soon as the first unit is fired by the camera.

When used for interior photography, the modelling lamps on the flash units give the photographer a rough idea of the quality and direction of the light, and are useful to check visually for any unwanted reflections in the picture. They do not give a correct indication of the intensity of the flash output in relation to the available light. This can only be checked by exposure calculation followed by shooting an instant-print test shot.

All integral flash units have a hole through them from one end to the other which acts as a socket for attaching umbrella reflectors, notably the black-backed white ones for purposes of interior photography.

Finally, lightweight collapsible flash stands are necessary for mounting the flash units. These usually extend to a height of around 2.5 metres (8 feet) and collapse to fit into a tailor-made shoulder bag that should hold three stands and three umbrellas. The flash units themselves are best protected and most portable in the specially made cases available. These are commonly designed to hold two or three units.

Meters

There are three different types of meter for measuring the strength or quality of light in architectural photography: a light meter for determining the brightness of the available light, both inside and out; a flash meter for measuring the strength of the flash output; and a colour meter for assessing the colour quality of light in an interior illuminated by artificial light sources. The light and flash meters are essential equipment, while the colour meter is an expensive optional extra for critical colour work.

Light meters

A light meter is necessary for determining the intensity of daylight illuminating the exterior and interior of a building. With a hand-held meter,

either direct reflected light readings can be taken, to measure the brightness of light reflected off a building; or incident readings to measure the intensity of light actually falling on the building. Different building materials have different reflective qualities, causing very light or dark buildings to yield inaccurate reflected light readings. While more consistent results can therefore usually be achieved using incident readings, reflected light readings can be successfully used so long as you are careful to take readings off medium bright surfaces (to approximate photographic mid-grey with 18% reflectance) under the same lighting conditions – see section on 'Exposure determination' in Chapter 7. Briefly, in terms of architecture, regular red brick tends to give fairly accurate reflected light readings, as does the rich blue of a clear sky on a sunny day. A sequence of such readings should enable you to determine an acceptable average as the basis for accurate exposure.

Another type of meter for reflected light readings off very specific areas is a spotmeter which has a 1° angle of measurement. A practical alternative, and at no extra cost, could be to use the centre-weighted metering system in an existing 35 mm SLR camera. Past experience with it should enable you to achieve consistent results.

Flash meters

Flash meters are a specific type of light meter that are used to measure the strength of the very short, bright bursts of light emitted from a flash unit. They usually record only incident readings, measuring the intensity of the light reaching the subject and displaying the necessary aperture for average exposure at pre-set shutter and film speeds. While an essential piece of equipment, this does not need to be the best or most expensive on the market: the cheaper meters still measure the flash intensity accurately. With interior photography especially, the meter readings need only act as a guide, since the flash is often the secondary light source to the dominant available light already in the room.

Colour meters

A colour meter measures the colour quality of light relative to the film type being used. Used largely for interior work, it records the colour temperature and any colour casts, and calculates the filters needed to balance the colour of the available light to the particular film type in use.

Incident readings are taken from within the picture area towards the camera. The light passes through a diffuser onto three separate silicon photocells, individually sensitive to blue, green and red light, respectively. The relative responses of these photocells are compared, displaying a read-out of any necessary filtration required. The filtration is divided into two scales: an amber/blue scale for colour correction; and a magenta/green scale for colour compensation. One filter from each scale is often necessary for the best possible balance.

It is an expensive item, useful for critical interior work, but not essential. Standard colour correction and colour compensation tables are printed in Chapter 4 and provide readily available guides to the filtration required for the various different types of light source.

Tripods

A tripod selected for the purpose of architectural photography must be robust and sturdy, with sensitive controls for fine-tuning the camera position. The long exposures demanded by interior work and the accuracy required for exterior work make a heavy-duty professional tripod essential.

Professional tripods are made up of two parts: the head and the set of legs, both of which are bought as separate items to suit the purpose for which they are required. The head should be heavy, with plenty of available movement in the three dimensions, and with large hand-sized handles for making fine and tight adjustments (Figure 3.3). A three-way head is adjusted by a turning a separate handle for movement along each of the three axes. It is much more suitable for the precise positioning and fine adjustments demanded by architectural photography than the ball and socket variety. It also helps to have the movement in each direction calibrated in degrees of angle. By zeroing everything, the operation of roughly setting up the camera in the first instance is speeded up, and any critical angle of view can be easily achieved. A quick-release plate is another useful, time-saving feature.

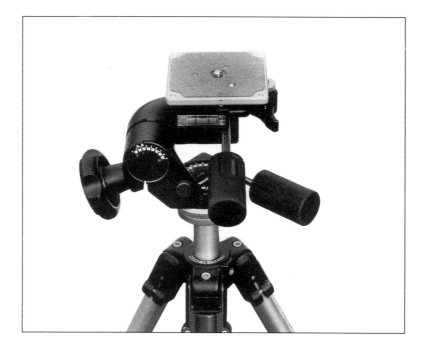

Figure 3.3 A three-way adjustable tripod head (Manfrotto 160 View Camera Head, courtesy of KJP) with quick-release mounting plate. The large handles enable fine and tight adjustments to be made in all three directions

The set of legs should be sturdy and able to extend to a height higher than eye level for the greatest flexibility. Ideally, it should also be black to avoid the problem of its own reflection in glass windows, for example. Screw tighteners are a better choice than clips for locking the legs in position as they avoid the possibility of a clip snapping off. Finally, the legs should have rubber feet to prevent any instability from slipping or sliding on a smooth floor.

Necessary extras

All camera and lighting equipment needs to be backed up with a bagful of essential extras. These include cable releases, flash synchronization cables, two or three extension cables, double/triple socket adaptors, Continental socket adaptors (if working abroad), and spare fuses for both the flash units and the plugs. A screwdriver with which to fit the fuses is required, and also spare modelling lamps, spare batteries for the meters and, if enough room, a roll of masking tape which has endless uses, including taping cables to the floor to prevent people tripping in a busy area. For exterior property brochure work, a hammer and pair of pliers are handy for removing unsightly agents' boards.

Film

In many other branches of photography, the photographer has to compromise film speed with quality in order to capture any movement with sufficient sharpness. The majority of architectural photographs are devoid of any subject movement and demand the use of a tripod, thereby affording architectural photographers the luxury of using high quality slow films as their regular stock (Figure 3.4). The slower the film, the finer the grain and therefore the sharper the images for reproduction. Where people do need to appear in an architectural shot, they can either be posed for clear definition, or allowed to continue their movement, resulting in a blurred action on film which is often considered a creative asset against the crisp structure of the building. The degree of blur can be varied according to requirements by varying the length of exposure, typically between 1/15 and 2 second.

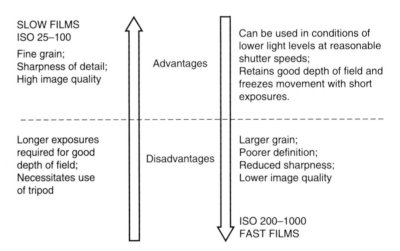

Figure 3.4 The qualities of films of different speeds

It is important to make comparative tests of your own to determine your personal brand preferences, and then to develop an intimate knowledge of just a couple of film types that will become your regular stock. The popular films in both colour and black-and-white are available in most formats, so the specific information outlined below applies equally to users of large format, roll film, and 35 mm cameras.

Colour transparency film

Colour transparency film is the popular choice of most commercial photographers working in colour, and is widely used for the purpose of mechanical reproduction. It produces an original image, as opposed to a print from a negative which is necessarily once removed from the original. Since the final published image is twice further removed from the original supplied by the photographer, it is essential to give the publisher an original of the highest possible quality from which to work.

Colour transparency films are available in two varieties: daylight balanced and tungsten balanced. The popular choice for regular exterior work is a professional slow/medium-speed daylight balanced film rated at ISO 100, for example a Fuji Fujichrome or Kodak Ektachrome transparency material. Slower films are available for even finer grain, and these are certainly an excellent choice for critical work under perfect conditions. Film with the ISO 100 speed rating, however, is the most versatile as regular stock and can be used successfully for both high quality exterior and interior work, as well as for dusk shots. For interiors, it requires no filtration when daylight through windows combined with flash is the primary light source, and suffers no reciprocity failure as long as exposures are no longer than a couple of seconds.

While daylight balanced film is fine for many interiors, the specialist film for interior work is tungsten balanced film rated at ISO 64. The reason for this is not so much for its tungsten balancing (though this can be useful when tungsten light is the only, or very dominant, light available in a large interior) but because it has been specifically designed for long exposures. It suffers no significant reciprocity failure between 1/15 second and 30 seconds, with minimal failure up to 1 or 2 minutes. For most interior work where daylight is the dominant light source an 85B colour correction filter is necessary over the camera lens, and this has the effect of reducing the effective film speed by one stop to ISO 32. The use of long exposures, even on such a slow film, enables the use of relatively small apertures under low-light conditions. These are needed to obtain sufficient depth of field throughout the image. Again, both Fuji and Kodak produce their own tungsten balanced transparency films, as do a couple of other manufacturers.

Both colour transparency and negative films, in roll and sheet formats, are frequently entitled 'professional' films. This means that the colour balance of the film is neutral at the time of production and therefore should be refrigerated until used to halt the ageing process. As film ages, its overall colour balance shifts, it becomes less sensitive to light, and its contrast diminishes. So when using a refrigerated 'professional' film, the photographer can be confident that the overall colour balance of the film will be as neutral as possible. General-purpose amateur films, on the other hand, are created to render a neutral colour balance after ageing for 3 months at room temperature.

To avoid any minor factory variations of colour balance it is best to shoot each assignment with film from the same batch (the batch number is shown on the side of the box along with the expiry date), in order to achieve consistent results. This is most easily done by buying film in relative bulk.

All colour transparency films use the Kodak E-6 process or equivalent for development (other than Kodachrome films, which have to be processed almost exclusively by Kodak themselves). The E-6 process

involves 11 stages, taking 1 hour to complete (inclusive of drying time), with a usual turnaround time of 2–3 hours in a professional laboratory.

Colour negative film

Although excellent colour prints can be usefully produced either directly, positive to positive, from a colour transparency, or indirectly via an internegative stage, colour negative film is still the most popular option when colour prints are the only desired end product of a shoot. The quality is obviously better than going via an extra internegative stage, and cheaper for long print runs than direct positive to positive prints from a transparency. The image quality is also quite different, and therefore choice of printing from negative or transparency is dependent both on requirements and personal preference.

A slow/medium speed film would be appropriate for architectural work, both exterior and interior, though for very long exposures it is still susceptible to reciprocity failure. Colour balance on negative film is not as critical as that on transparency film, as minor colour variations at the time of exposure can be filtered out at the printing stage to produce the desired colour balance.

Since negative film alone cannot, by definition, produce a positive image for viewing, the quality of the final image is as dependent on the paper on which it is printed as the film on which it was taken. For these reasons, experimentation under the same conditions is the best route for discovering your personal choice of film/paper combination, concentrating on the comparison of tone, detail sharpness, grain size, and the richness and accuracy of the colour rendition.

Colour negative films are developed using the Kodak C-41 process or equivalent. This is a seven-stage process that takes approximately 45 minutes (inclusive of drying time), with a turnaround time of anything from one hour in a professional laboratory.

Black-and-white film

There are two main uses of black-and-white film for purposes of architectural photography: for the archival recording of buildings; and for dramatic, artistic effect in advertising brochures. The archival recording of buildings is best exemplified by the photographers of The National Monuments Record in the UK. A medium/slow film rated around ISO 100 is the recommended regular film stock for such work due to its flexibility and consistent high quality results. While fill-in flash is recommended for most interior photography to reduce the contrast in an interior to recordable levels, it is possible with black-and-white film to control contrast to an extent by over-exposing the film in the camera and then reducing the development time accordingly. Contrast can be further reduced or boosted at the printing stage depending on the contrast balance of the printing paper you choose. If complicated exposure/development variations are likely to be a regular part of your work then it would probably be sensible to process and print your own films, as your experience will be the best guide to achieving perfect results.

The advantage of using black-and-white film for the archival recording of buildings is that they have proved their durability over a long period of

Figure 3.5 Black-and-white film is the ideal medium for the archival recording of buildings, having proved its durability over a long period of time, and is more consistent than colour for the direct comparison of shots. This photograph was taken at the turn of the century by William Dunn (great-grandfather of the author) of the Forth Railway Bridge in Scotland under construction

time if stored correctly, and are not prone to the potential fading of synthetic dyes in colour films (Figure 3.5). Furthermore, photographic archives on black-and-white film and paper are more consistent for the direct comparison of shots taken at different times than a variety of colour films with slightly different colour balances and varying degrees of fading.

The most dramatic black-and-white film for artistic effect is infrared film with its grainy, high-contrast, ghostly results. Available in 35 mm or sheet film form, it is sensitized to respond both to infrared wavelengths and much of the visible spectrum. To maximize its dramatic effect, it is necessary to use a visually opaque filter that transmits only infrared. This causes green vegetation to glow a fuzzy shade of white and, on a bright sunny day, makes white clouds stand out boldly against a blackened sky. For a fuller description on the use of this type of film, see the section 'Black-and-white infrared photography' in Chapter 9.

For less dramatic, yet crisp artistic or abstract images with relatively high contrast, a slow ISO 25 film is an appropriate choice, in conjunction with a fine-grain developer. When processed the grain of the film is so fine as to be invisible to the naked eye for most standard enlargements. The effect of this film can be enhanced by darkening blue skies with either a red contrast filter or polarizer to make white clouds stand out starkly.

By comparison with colour film, black-and-white film with its simpler emulsion is both forgiving and easy to use. It is tolerant of minor exposure variations, and obviously avoids any problems caused by unwanted colour casts from artificial light sources in interiors. It is also flexible in the way it can be processed and printed, enabling a wide range of possibilities for the final print in terms of grain, contrast and sharpness.

Instant-print film

The importance of instant-print film, available in both colour and black-and-white, cannot be overstated. When used in an instant-print magazine back or film holder that has been interchanged with the regular film back

or holder on the camera, it can produce a positive image of the precise image you are intending to take in only 90 seconds after exposure. It enables you to check composition and lighting, and the approximate effect of any filters being used, especially graduated ones. It also provides a check as to whether any vignetting of the image is taking place as a result of excessive shift movements (see Figure 7.2 in Chapter 7), which can be difficult to assess from the viewing screen alone. Basically, it gives you unprecedented confidence that what you believe you are recording on film you will successfully be recording on film when you change film backs or holders.

There are several type of instant-print films available, matched to the film speeds of the popular film types. Polaroid Polacolor Pro 100 film is a daylight-balanced colour film rated at ISO 100 – ideal when used in conjunction with ISO 100 daylight-balanced transparency film. This produces a positive image 90 seconds after exposure at temperatures between 21°C and 35°C. Processing time is increased to 120 seconds at 16°C.

Similarly, Fuji FP-100C film is also a daylight balanced colour film rated at ISO 100, and the processing time varies with the ambient temperature from 180 seconds at 15°C to 60 seconds at 35°C.

When working with ISO 64 tungsten-balanced film for interior work, the perfectly matched instant-print film is Polaroid Polacolor 64 Tungsten film. With this material, film speed is nominally kept constant along with processing times, but exposure adjustments of a third of a stop must be made according to the ambient temperature.

For black-and-white work, Polaroid T664 (medium format), T554 (5 × 4 in. pack film) and T54 (5 × 4 in. sheet film) rated at ISO 100 are the most popular, though other types are available. These include T665 on medium format, rated at ISO 80 that produces a print and a re-usable negative, and T55 (5 × 4 in. sheet film) which is similar.

Matching the instant-print film to the colour transparency or negative film to be used overcomes the need to make complicated exposure calculations between films of different speed, and is therefore preferable, though not obligatory. Precise processing times or exposure adjustments are clearly detailed on each pack.

The instant-print magazine back on a camera sometimes produces a larger image area than the subsequent transparency or negative film size will allow. If this is the case, it is important to carry a transparency-sized mask to show you the precise image area that will be recorded on film. The advantage of having a larger image area on the instant print is that it enables you to shift the mask around to check that composition for the film area is perfect. If it is not, you can make a lens shift on a view camera corresponding to the mask shift on the instant print without affecting the focus. Always re-check any changes you make by taking a further instant print.

4
Filters and their uses

Introduction

Photographic filters are coloured or textured discs of glass, plastic or gelatin placed in front of the lens in order to modify the colour or quality of light passing through it onto the film plane, thereby altering or enhancing the recorded image.

Filters for architectural work fall into four main divisions: first, the ultraviolet (UV) and the polarizer types which are colourless light modifiers; second, special effects filters which include graduated filters as well as, for example, the more dramatic starburst type; third, colour correction and compensating filters which are used largely for interior work to balance the colour of the ambient light with the colour balance of the chosen film-type; and fourth, filters for black-and-white photography, including those for infrared work.

Ultraviolet

The ultraviolet absorbing filter is the basic standard filter that appears as a simple piece of clear glass, and is used by most photographers as a permanent lens protector, only to be removed when other filters are to be used. Its actual effect is to absorb the scattered ultraviolet in the atmosphere that is not visible to the naked eye, but would otherwise exaggerate any visible haze on film. The circular screw-mount variety are the most useful, as they effectively seal the front lens element from dust or scratches. UV filters can be simply and cheaply replaced should any damage occur to them, while a scratch to a front lens element is likely to be costly and time-consuming to repair.

Polarizer

The polarizing filter, dark grey in appearance with an exposure factor of around 4 (requiring a two-stop exposure increase), can reduce or eliminate polarized light from the subject. One effect of this is to reduce or eliminate reflections from shiny non-metallic surfaces. Reflections from such surfaces, notably windows for purposes of architectural photography, are almost totally polarized, enabling almost total elimination when filtered at an optimum angle to the surface of approximately 33°. Another effect is to

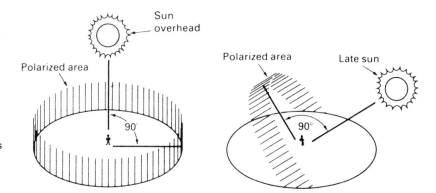

Figure 4.1 Light is most polarized in the arc of the sky that is 90° from the sun. It is this arc that can be darkened with the use of a polarizing filter for richer colour saturation

darken a clear blue sky on a sunny day either for a richer saturation or to enhance the prominance of any white clouds in the image.

While unpolarized light waves vibrate randomly, polarized light waves are restricted to one particular plane. The axes of the molecules in the filter material have been aligned in a parallel structure. When these axes are parallel to the plane of polarization, light is transmitted. A rotation of the filter to a position at right-angles to the plane of polarization prevents the polarized light from passing through.

The rotational orientation of the polarizer enables varying degrees of reduction of reflection and the darkening of blue skies (Figure 4.1). Light is most polarised in the arc of the sky that is 90° from the sun, and least polarized at 0° (i.e. close to the sun) and 180° (opposite the sun). To locate this arc, extend your arm and point to the sun with your forefinger. Next, stick your thumb up and turn your wrist in an arc. Your thumb will be pointing to the arc in the sky where the light is most polarized when you make this movement. The further you travel from the equator, either north or south, the greater the degree of polarization in the light, and therefore the more effective the polarizer for darkening the skies.

Finally, a word of caution. Do not automatically use a polarizer when there is a blue sky, and do not always rotate the filter for maximum effect as this can cause the sky to be reproduced so dark that it resembles a night sky. Take special care when using the polarizer with wide-angle lenses as the contrast between the darkened arc of polarized light and the lighter unpolarized area of the sky can appear unnatural.

Graduated filters

Graduated filters are half toned and half clear filters with a smooth and even transition from tone to clear, which can subtly darken or colour skies in architectural landscapes. Most subtle of all is the graduated neutral density filter, available in different strengths, which can reduce the contrast between cloud cover and architecture to recordable levels. Neutral density (ND) filters are grey and colourless, thereby reducing the level of light by set exposure factors without affecting the colour of the image. Graduated ND filters can also be useful when photographing the full frontal elevation of a building in a confined street on an overcast day. The top section of the building can be a whole stop brighter than that at ground level, and can be subtly corrected using such a filter with an exposure factor of 2 (NDx2).

Graduated filters are available in a variety of different colours and strengths, notably blue and tobacco. The blue is useful for adding a hint of blue to an otherwise overcast or hazy sky. The weaker strength filters are for compensating either for haze on an otherwise sunny day, or to restore the colour to a blue sky when the building is not situated directly opposite the sun. The stronger strength blue filters will have the effect of converting a bright overcast sky into a blue one, as demonstrated in Plate 1. The tobacco filter can subtly enhance the stormy appearance of a sky for effect. All coloured filters should be used cautiously, with great subtlety so as not to appear intrusive.

The effect of a graduated filter in a photograph is more pronounced the greater the depth of field, as with a wide-angle lens at a small aperture. Conversely, the transition is more subtle the longer the focal length of the lens and the wider the aperture. Always check the effect visually, as best you can, with the aperture stopped down. If you are in any doubt over the correct positioning, strength of filtration or aperture selected, check the results on instant-print film.

The most flexible type of graduated filters are large rectangular ones which can be shifted up and down within a rotating holder. Their use, however, is limited by their straight linear graduation. When a building fills most of the frame, with an inverted V-shaped gable jutting into the sky, graduated filters are rendered useless if they are not also to darken the top of the building itself. This problem can be overcome by the use of selective filtering, outlined in the next section.

Selective filtering

Selective filtering achieves results similar to those of graduated filters, but involves tailor-making your filter for a specific shot in order to add colour or graduation around roofscapes of any shape. You place a full-size gelatin filter, of the desired colour and strength for the sky, over a clear glass filter in the filter mount. Then, while looking at the image on the focusing screen (stopped down to a working aperture as wide as possible for the most subtle transition), you trace the outline of the roof-scape on the gelatin filter with a chinagraph crayon. You then remove the gelatin filter and cut it along the traced line. Either use this as a template for cutting a new, clean filter, or clean it carefully and thoroughly to remove any trace of the chinagraph. Then replace it in the filter holder, and align it with your roof-scape. A perfect shading of the sky around the awkward roof-scape can now be achieved.

Other effects filters

The use of most special effects filters should be severely restricted for serious architectural work as their effects tend to be gimmicky and artificial, and lacking in subtlety. Diffusers, including fog filters, multi-image filters, sunset and even rainbow filters are all readily available, but not for the use of the architectural photographer. Occasional use of a starburst filter can add drama either to the reflection of direct sun off a window (see Plate 2) or to any point sources of light in a night scene. Often the modest starbursts produced by the lens itself are the most attractive.

green (G), and blue (B), and their complementary opposites cyan (C), magenta (M), and yellow (Y), all in varying densities. In combination or alone these filters can fine tune the colour balance of almost any lighting situation when used in conjunction with a colour meter (an instrument that measures the colour quality of light in an interior, relative to the film type being used, and calculates any filtration necessary).

Colour compensation tables (see Table 4.1) refer to appropriate colour compensation in terms of a numerical density or strength, followed by the initial of the colour of the particular filter, or filters, required for the situation. They frequently also give the exposure increase necessary in terms of *f*-stops for the recommended filtration. For example, the filtration needed to compensate the colour of light from a 'daylight fluorescent' lamp for reproduction on a daylight-balanced film is recorded as 'CC 40M + 30Y, 1 stop'. This means that filtration with a strength of 40 Magenta plus 30 Yellow is required over the camera lens, with an overall increase in exposure of one stop.

While critical colour compensation in situations of fluorescent lighting requires the use of a specific combination of colour compensating filters for perfect results, there are readily available fluorescent compensating filters for either 'daylight-fluorescent' (FL-DAY) or 'white-fluorescent' (FL-W) which are adequate for most general uses, and when not in possession of a colour meter.

Colour filters for black-and-white photography

The colour filters for black-and-white photography fall into two categories: correction filters and contrast filters. Correction filters are necessary because most general purpose black-and-white films are panchromatic sensitized materials which are not uniformly sensitive throughout the spectrum. Most are more sensitive to blue than green. In order to record the colours of the subject with their true luminosity, a yellow-green full correction filter should be used, though this has a filter factor of 4 (requiring an exposure increase of two stops). A yellow partial correction filter, with an exposure factor of 2, is often more popular, and can be used as the standard filter over the lens at all times for black-and-white work when no other filter is employed.

Contrast filters are the brightly coloured filters for use with black-and-white film. Often more popular than correction filters, they are used to adjust the tonal contrast of certain parts of the subject image. For example, without filtration, oranges and greens can appear the same shade of grey on film. A contrast filter is required to produce the desired tonal separation between these different coloured areas when reproduced in black-and-white.

A coloured filter allows light of its own colour to pass through it, but absorbs the other colours, especially those furthest from it in the spectrum. The effect, therefore, on black-and-white film is that a coloured filter will darken the opposite colours in the subject, and lighten those that are the same. Consequently, a red filter can be used to darken a blue sky, for example, at the same time lightening any red brickwork. It does, however, also darken any green foliage. If there is much foliage present a green filter may be more appropriate as it has the effect of lightening green foliage, though it will also darken red brickwork. Whenever you decide to use a contrast filter, you must always consider its effect on all parts of the image,

Filter	Wratten No	Daylight exposure increase	Use
Yellow	8	1 stop	A subtle standard for toning down blue sky, slightly lightens foliage, and lightens yellow stonework.
Green	58	3 stops	Tones down blue sky, darkens red brickwork, lightens green foliage revealing greater detail.
Orange	21	$2\frac{1}{3}$ stops	Darkens blue sky and green foliage, lightens red brickwork and yellow stonework for improved contrast. Reduces haze.
Red	25	3 stops	Dramatically darkens blue sky and foliage creating a thunderstorm effect. Lightens red brickwork and generally increases image contrast. Reduces haze.

Table 4.2 Contrast filters for black-and-white photography

not just the main subject matter. Table 4.2 summarizes the uses of the most popular coloured filters for black-and-white photography.

One further use for a strong red filter is for purposes of black-and-white infrared photography. The colour sensitivity of high-speed infrared film has been specially extended to be sensitive to infrared radiation far beyond that which the eye can see. The effect is grainy and ghostly, turning blue skies black, and green foliage snowy white. However, its unusual effect can only be properly realized if either a red filter (typically a Kodak Wratten 25 red) is used to cut out the ultraviolet and blue light; or for the most surreal and dramatic effect, a visually opaque filter (typically the Wratten 87) that eliminates virtually all visible light, transmitting only the infrared radiation. Fuller detail on the practice of infrared photography is to be found in Chapter 9.

Filter mounts

Filter mounts basically take two different forms: either, as an integral part of the filter, they are circular, and screw into the front of the lens casing, or they are square into which different filters can be placed. The latter are considered universal as different sized adaptor rings can be attached to correspond with the different diameters of your lens barrels. The square variety is both the most flexible and the cheapest as with the different adaptor rings, one filter can be used with all lenses. It can also take gelatin filter mounts. The circular integral filters are the obvious choice for semi-permanent lens protecting filters: the ultraviolet for colour photography, and the yellow partial correction filter for black-and-white work.

5

Composition

Introduction

> The permanent element in mankind that corresponds to the element
> of form in art is man's aesthetic sensibility.
>
> Herbert Read,
> *The Meaning of Art* (Faber & Faber, 1972)

The task of the architectural photographer is to convey the aesthetic appearance of a massive three-dimensional building, as effectively as possible, onto a small two-dimensional sheet of film. In practice, it usually needs several sheets of film and includes both detail and interior shots of the building as well as general exterior views. However, the same fundamental principles of composition underlie all the different types of shot so it is important for the photographer to understand them thoroughly in order to be able to apply them in practice on assignment.

The three main elements of composition are structure, line dynamics and perspective. Structure is concerned with organizing the different parts of the image into a harmonious whole within the borders of the film frame. Dynamic lines are those within the subject image that are juxtaposed at exaggerated angles for visual impact, and are created by visualizing the image in a purely linear, two-dimensional abstract way. Finally, perspective produces the illusion of depth on a two-dimensional surface, enabling the viewer to differentiate size and distance in the image.

Structure: symmetry

The simplest form of compositional structure is symmetry whereby both sides of the image are identical, but opposite, around a vertical central axis. The simple, clean perfection of this type of composition is both its strength, and its corresponding weakness. Unless a building demands such treatment through the perfect symmetry of its own structure, symmetrical images can appear dull and unimaginative. Straight symmetrical shots of the exterior of buildings usually need something extra to justify such simple treatment. They also need to be executed with absolute technical precision.

The photograph of the front entrance of a converted grammar school on the cover of this book is a good example. Extra impact was added by adopting a very low vantage point, deliberately causing the verticals to converge, and allowing the dominant handrail to lead the eye into the

picture. The shape of the rounded canopy is mirrored both by the rounded steps and the rounded brickwork underneath the pointed gable. Such a well thought-out and beautifully designed symmetrical construction demanded symmetrical photographic treatment.

Again with interiors, certain massive symmetrical atria, or classic Georgian entrance halls can demand symmetrical treatment. The sterility of the symmetry is frequently offset by an asymmetrical staircase, or asymmetrical furnishings which add the extra interest and impact often needed in such a shot.

Structure: Law of Thirds

We have seen that to choose a symmetrical composition, the building being photographed has to be outstanding in its own symmetrical perfection. The picture area, divided into two equal parts is a fundamentally uninteresting arrangement – see Figure 5.1(a). A more interesting framework for composition is a division away from the centre, typically dividing the rectangle or square into a third and two-thirds, as shown in Figure 5.1(b). Taking this theory one step further, a frame divided symmetrically around both a vertical and horizontal axis produces a picture divided into four rectangles of equal size, as in Figure 5.2(a). Conversely, Figure 5.2(b) shows a frame divided into thirds around both a vertical and horizontal axis. This produces four rectangles all of different sizes, juxtaposed to create a much more interesting composition.

Thus, a composition with the main lines of the image constructed along the thirds, and any specific focal points placed at the intersection of a vertical third with a horizontal third is likely to create an appealing shot. This is the principle behind what is commonly called the Law of Thirds, an

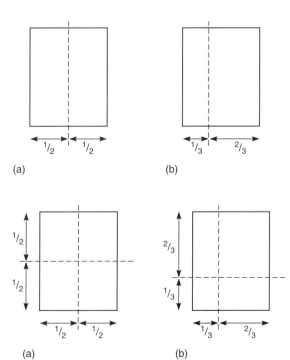

Figure 5.1 Drawing (a) shows a simple symmetrical division of the picture area around a vertical axis into two equal parts; while drawing (b) shows a more interesting division away from the centre into a third and two-thirds

Figure 5.2 Drawing (a) shows the picture area divided symmetrically around both a vertical and horizontal axis, producing a picture divided into four rectangles of equal size. Conversely, drawing (b) shows the same area divided into thirds around both a vertical and horizontal axis, producing four rectangles all of different sizes, juxtaposed to create a much more interesting composition

Portrait Landscape Square

Figure 5.3 The division of the three basic photographic formats according to the Law of Thirds

approach to composition that universally appeals to our sense of beauty, and one which applies to all forms of picture making, and therefore all branches of photography.

Having intersected the frame along the thirds, in both directions (see Figure 5.3), the Law of Thirds states:

a. The main subject(s) should be positioned on or near an intersection of the thirds.
b Some other element of the picture should lead the eye towards the main subject.
c The main subject should contrast with the background, either in tone or colour.

This Law applies to general view exteriors, interiors and detail shots, and Figure 5.4 shows some typical applications.

With general exterior views, the skyline and sometimes the road line can lie approximately on the horizontal thirds, with the corner of the building lying close to a vertical third. In a general view interior, the perspective can

Figure 5.4 Some typical applications of the Law of Thirds in the practice of architectural photography. The dotted lines mark out the thirds to demonstrate how the Law has been applied to a typical exterior, interior and detail shot (a)

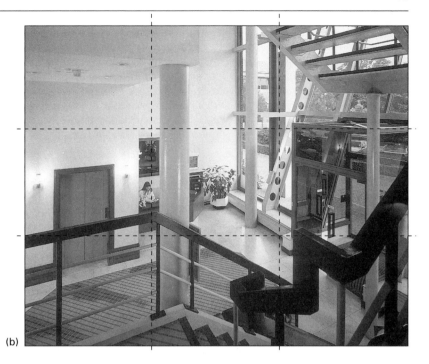

(b)

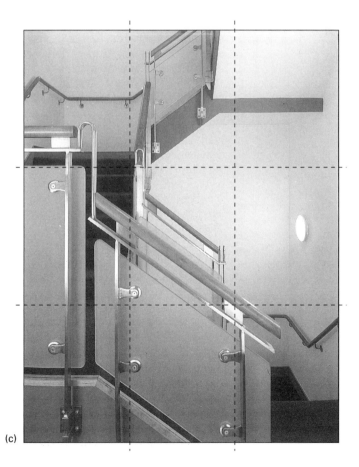

Figure 5.4 (b) and (c) (c)

lead the eye to the far wall, the centre of which can be at the junction of a vertical and horizontal third.

The Law does not have to be adhered to strictly. In fact, the most interesting shots often deviate from it quite dramatically, and it is this deviation that puts the photographer's individual stamp on an image. Whatever the deviation, however, the photographer should be aware of the Law in order to understand how it can be successfully adjusted to his or her preferred individual approach.

Line dynamics

When a composition is viewed in a purely two-dimensional abstract linear way, those lines in the picture that are out of parallel with the edges of the frame are considered dynamic. The closer their angles are to 45° (i.e. half way between vertical and horizontal), and the more dramatic their juxtaposition at opposing and unequal angles, the greater the sense of excitement generated within the image, and therefore, the more powerful its impact. If the camera is tilted 45° for deliberate dynamic abstract effect on a detail shot, the sight of brickwork or a street lamp, for example, at a 45° angle disturbs our sense of gravitational normality and at the same time stimulates our creative thirst for an alternative approach.

Dynamic lines that exist naturally within a composition (without any deliberate camera tilting) exercise the same effect on our mind. This is because they upset our sense of perfect balance, of a person standing upright on level ground, that is most simply depicted by a vertical line resting on a horizontal line. Horizontal lines in a composition express a sense of level tranquility, while vertical lines represent gravitational stability. By contrast, dynamic lines appear directional, agitated and unresolved, but they add that daring vitality to a potentially perfect, yet sterile, image.

A fine example of the use of dynamic lines for impact in an architectural photograph is when a low vantage point is selected for shooting a perfectly symmetrical front elevation of a building. Instead of correcting the verticals with shift movements, the verticals are deliberately left to converge, as illustrated again by the cover shot.

When photographing a building from an angle, the use of a wide-angle lens can exaggerate the perspective, thereby enhancing the line dynamics. The closer one is to a building, the wider the lens needed for a full general view, and therefore the greater the perspective distortion with its correspondingly exaggerated line dynamics – see Figure 2.9 in Chapter 2.

Perspective and three-dimensional structure

In the photography of architecture, line dynamics are the most significant mechanism by which perspective produces the illusion of depth on a two-dimensional surface. Lines converging to one or more vanishing points cause the subject to get smaller as it recedes into the distance. Thus linear perspective is the primary factor that demonstrates the three-dimensional structure of a building when reproduced on film, along with contrast and tone which naturally also play their part.

Figure 5.5 A 60°/30° perspective on a building represents it as a solid structure and not just a facade, while emphasizing the front elevation

When approaching a building for purposes of photography, it is important, where possible, to be thinking of representing it as a solid structure and not just a facade. For a general view, concentrate on the front elevation, but also allow a more oblique view of the side elevation to appear in the shot where possible, typically a 60°/30° perspective as illustrated in Figure 5.5. The frame can be divided roughly into thirds: two-thirds for the front elevation, and one third for the side elevation as shown in Figure 5.4(a). This is obviously not possible with a terraced property, though a side angle shot along the terrace with the whole of the relevant elevation in the foreground allows diminishing perspective to suggest depth in the image.

A straight-on front elevation shot will inevitably be two-dimensional in appearance except for any three-dimensional texture details on the surface of the structure. This can be a useful additional shot, as a photographic extension of the architect's original front elevation drawing, but is not often used as the main general view of a building.

Focal length variations for alternative visual interpretations

The visual effects of lenses with different focal lengths vary enormously from the dramatic perspective enhancement of a wide-angle lens, to the compressed image produced by a long-focus lens (Figure 5.6). Both effects actually come about as a result of changing the viewpoint as this is the only action that can alter the perspective in a photograph. The wider the angle of view, the more you can see of the lines that are converging to one or

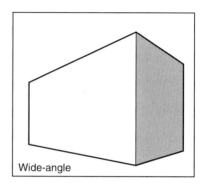

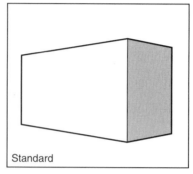

Figure 5.6 A comparison of the effect on perspective when a building is photographed from different distances, using different lenses to fill the frame. It is the varying of the distance rather than the type of lens used that causes the changes in perspective

more vanishing points. The narrower the angle of view, the less you can see of these lines.

The standard lens lies mid-way between these two extremes, with a focal length equal to the diagonal measurement of the film frame. In other words, the diagonal measurement of a film frame on medium format is approximately 95 mm for 6 × 7 cm, and 110 mm for 6 × 9 cm. Consequently, the typical standard lens for medium format has a focal length of 100 mm. Similarly, the typical standard lens on 5 × 4 in. large format is 180 mm. Wide-angle lenses have focal lengths shorter than the standard for a particular format, and long-focus lenses have focal lengths longer than the standard.

The focal length of the standard lens and hence field angle of view, relates to that of the human eye, and so the images it produces appear to have the most natural perspective. Perspective is altered by changing the distance of the camera from the subject, usually accompanied with a change of the focal length of the lens used. More simply, to include the same amount of the building with a wide-angle lens as with the standard, you would have to move closer to it. The effect of this is exaggerated perspective that both enhances the dominance of the building and the dynamic structure of the image. It creates a more punchy and exciting shot, that is well suited to the linear nature of much modern architecture. A wide-angle lens is also a popular choice when space is restricted, as in city streets, for example.

The use of a wide-angle lens is, however, limited when the roof structure of a building is an important element to include in the photograph. The close vantage point demanded by such a lens can be too close to the building to be able to see the roof structure at all. In such circumstances, a lens of longer focal length and a more distant viewpoint is necessary.

Plate 1: The use of a graduated filter can subtly enhance a sky in an architectural landscape. These two images were taken to show the attractive view from a building towards the sea.

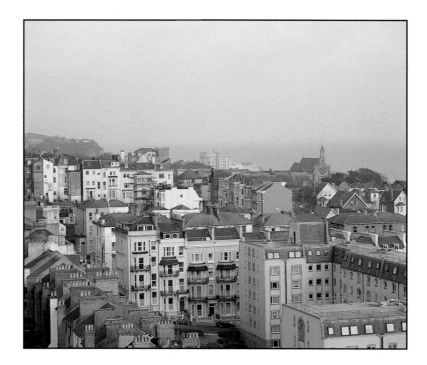

Image (a) shows how the colourless haze and weak sunshine yielded a flat and lifeless image without filtration.

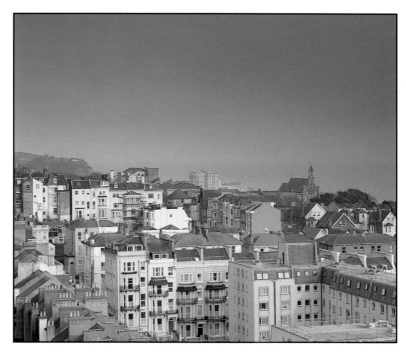

Image (b) was taken only moments later using a strong gradual blue filter which has significantly boosted the impact of the image, giving it an almost Mediterranean vitality.

Plate 2: The occasional use of a starburst filter can add drama to the reflection of direct sun off a window (NETC building).

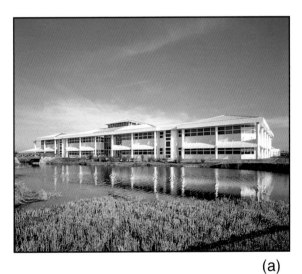

(a)

(b)

Plate 3: Exterior photographs of the NETC building to demonstrate some of the typical types of view expected by an architectural client. Image (a) shows an angled front elevation shot of the whole building; image (b) shows a detail shot of the structure; and image (c) shows a purely abstract photograph – of the entrance canopy.

(c)

Plate 4: Some typical interior views.

Image (a) shows a reception shot;

Image (b) shows a dramatic stairwell photograph, taken as an abstract feature shot; and image

(c) shows an open-plan floorspace enhanced by sunshine patterning.

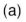
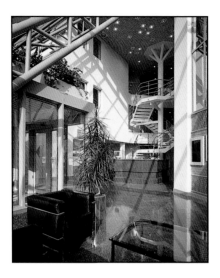

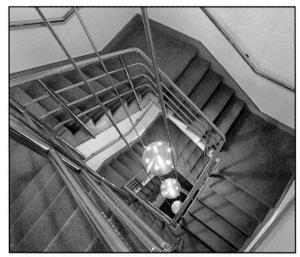

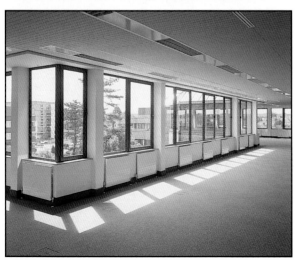

Plate 5: This photograph of Kenwood House on Hampstead Heath, London was taken using an excessive rising-front shift movement to dramatically expand the sky area while retaining perfect verticals in the image.

Plate 6: A typical night shot, actually taken at dusk. The sky retains sufficient brightness for the outline of the building to be satisfactorily silhouetted. Uniformity of the interior lighting is essential for such shots.

Plate 7: Balancing primary colours. The bright red of the car combines perfectly with the yellow showroom signage and rich blue sky to complete the primary combination, creating a visually satisfying and resolved image.

Conversely, to maintain the same amount of the building with a long-focus lens, the camera has to be moved further from the subject. This has the effect of flattening the perspective, compressing the space between the subject and its background. This lens is useful for showing a tall building within its context of a city skyline, for example, although its use is most often restricted due to lack of space or suitable vantage point. It is also useful for selectively isolating a building within its landscape.

Remember also that depth of field in the image varies with focal length. The shorter the focal length (the wider the angle of the lens) the greater the depth of field in the image for a given aperture. The longer the focal length of the lens, the smaller the depth of field for that same aperture. Consequently, longer lenses require the use of smaller apertures to achieve sharp focus throughout the depth of the image. This can be achieved by using longer exposure times.

Creating a set of photographs of one building

Clients vary considerably in terms of how detailed a brief they give you when commissioning the photography of a building. Some rely on your experience and past working relationship together to come up with suitable shots for the purpose for which they are required. They expect to see a selection of photographs that best convey the location, size, amenities, quality, detail and atmosphere of a building, emphasizing different aspects depending on the nature of the client. However strong your client relationship, it is always worth pressing the client for as much detail of his requirements as possible to avoid disappointment and the aggravation of a re-shoot.

Other clients are extremely specific, and will come on site to show you the precise shots they have carefully worked out in advance. This both takes the responsibility of selection away from the photographer, and saves time not having to shoot alternative angles. For example, one leading property agent had worked out the perfect way of eliminating the appearance of unsightly and intrusive ceiling ducting that ran the full length of a reconditioned office building. By standing directly below the boxed ducting, its side could be visually aligned with the line of the ceiling tiles, on the viewing screen. Selecting a low vantage point prevented the top of the windows at the end of the line of ducting from being obscured by it, which would otherwise have given the game away. A masterful plan of creative deception, the forte of property agents, which required precision alignment and careful lighting to maintain the two-dimensional appearance of the ducting, but was otherwise easily executed.

This section aims to outline the type of shots that combine together neatly to create a representative set of photographs of a building from a broad brief, typically either for an architect or for use in a smart property brochure. Generally speaking, it is easiest to work from the general views to the particular details, as that is the way we naturally size up and come to terms with buildings we see for the first time. It can be difficult to appreciate the significance of some of the detail without having worked on its context, i.e. the building as a whole.

Finally, when creating a set of photographs remember to vary both the format and your shooting angle between shots. Let the building or detail, by virtue of its vertical or horizontal nature, determine whether you shoot it 'portrait' (as a vertical shot) or 'landscape' (as a horizontal shot). Try

also to vary these, unless specifically directed otherwise. With regard to your shooting angle, you do not want to end up with a set of photographs all receding to the left of the image, for example. Just as people are either left-handed or right-handed, most photographers have a tendency to shoot from the same angle when a building allows the photographer the choice.

Exterior photographs

The first impression we have of a building is often its semi-distant appearance in the landscape. This can either be favourable or unfavourable, depending on how comfortably the building sits within its environment. At this range, the distances between potential accessible vantage points in a wide radius around the site can be considerable, and therefore time-consuming to explore. As a result, it is usually best to leave such photographs till later, when you have the major shots under your belt, and your time feels at less of a premium. It is not worth spending a couple of valuable hours at the start of the day locating the perfect vantage point for a situational shot. You could end up finding the sun disappearing fast from the more important on-site general view shots, with your time under undue pressure.

The angle at which the building lies relative to the movement of the sun will determine whether you start with the exterior or interior of the building. Assuming the sun is correctly positioned on your arrival (see Chapter 6), it is best to start with the on-site general exterior views. While interiors are often much improved with direct sunlight, it is usually quite acceptable to shoot them without, so sunshine priority should always be given to the external shots. Diffuse natural light internally from an overcast sky is always preferable to a grey, lifeless exterior on a cloudy day.

The general exterior views (see Plate 3) are likely to include a straight-on front elevation photograph (as in Figure 9.4 in Chapter 9) and an angled front elevation shot to show the three-dimensional structure of the building. These, of course, should be taken with a view camera and verticals fully corrected. The shape of the building itself usually determines whether the building is photographed on a horizontal ('landscape') format, or vertical ('portrait') format, though in some instances this may be dictated for purposes of layout. It is always worth checking this with the client in advance.

Beyond these main front elevation photographs would be any relevant detail shots and perhaps some exciting abstract images of part of the elevation for visual impact in a brochure (see section on 'Abstract detail shots' later in this chapter). These are often taken looking up at the building from an extreme angle, or by tilting the camera itself, or a combination of both.

Depending on the nature of these detail or abstract photographs, they can either be taken with a view camera if the vertical structure of the building is a dominant element of the image, or more conveniently with a SLR camera. The latter greatly simplifies finding such shots, especially the abstract ones, as it enables you to wander around while constantly viewing the actual image through the viewfinder. It also speeds up the operation and encourages that spark of spontaneity that often leads to rewarding results.

Interior photographs

With a selection of sunny exterior shots under your belt, you can now confidently turn your attention to the interior of the building (see Plate 4). Note how the main interiors lie relative to the angle of the sun, and schedule your interior work accordingly to make the best use of it. With commercial buildings there is usually a reception area that will need to be photographed; often a boardroom as the smartest room in the building; sometimes an attractive stairwell; and then the open-plan floors which if unfurnished can benefit enormously from direct sunshine creating abstract patterns across the empty floor-space. There may also be other interesting rooms, features or details that need to be covered.

Before starting, always spend time to work out the photographs that are required, and their logical shooting sequence. This should be designed for the minimum movement of equipment between shots as well as taking into account the angle of the sun. A sequence that I find works well in large buildings is to start at the top and work my way down the building. This is because it is easiest to transport fully packed equipment in a lift to the top floor, and carry it down the stairs piece by piece as required. I find that having started a shoot, it is quicker to move the equipment to the next location piece by piece than to pack it up between shots.

Where possible, shoot as much as possible on one floor of the building to be economical with your time. This is quite acceptable practice as often one floor is better fitted out, or has larger windows and higher ceilings than the other floors, and therefore creates the most favourable image of the building.

As you take the main interior shots, do not forget to photograph any interesting features that could make useful interior detail images. Again these can either be photographed with the view camera that you have used to shoot the interiors, or with a SLR camera for speed and ease of use. Dramatic shots of stairwells – either looking up or down – are certainly more easily taken with a SLR camera than a view camera, for example.

When you feel you have fulfilled your brief and adequately covered both the exterior and the interior of the building, you can confidently pack away your equipment. If time and weather conditions permit, you can now spend some time if you choose to find a suitable vantage point for a more distant situational shot. This should show the building within the context of its environment, and is likely to be taken with a long-focus lens.

Abstract detail shots

Abstract detail shots enable a client to present the style and quality of a building by isolating representative features of it. They can also add a dynamic impact to a brochure of otherwise perfect, but straightforward, general elevation and interior photographs.

The photographer must identify the interesting details or features that warrant such treatment. These can sometimes be thematic, with a particular shape or pattern being echoed around the building, both inside and out. Such themes make the task of isolating suitable features fairly simple. For buildings without such thematic features, look for quality finishes. Internally, these can include doorhandles, light fittings, stair-rails etc., and any interesting juxtapositions of two or more of these items

Figure 5.7 The careful juxtaposition of the spiral staircase with the doors and light-fittings creates an exciting abstract detail shot to demonstrate style and quality in the building

(see Figure 5.7). Typical exterior details can include unusual structural features, the junctions of walls with roofs, windows, doors etc.

Most abstract detail photographs are taken in one of three ways. First, they can be taken with the camera parallel with the elevation of the building, with the full abstraction lying within the structure of the building itself (Figure 5.8). This could be a small or large section of the building, isolated out of context to create an abstract arrangement in its own right. Second, they can be photographed from an oblique angle to the building (either vertically or horizontally), preferably with a wide-angle lens to enhance the perspective impact. Or third, the camera can be tilted at an angle, often facing the building with a standard lens. This has the effect of

Figure 5.8 This abstract exterior shot of the NETC building was taken with the camera parallel with the elevation of the building. The full abstraction lies within the structure of the building itself rather than having been shot at an oblique angle for dynamic effect

converting the vertical and horizontal lines of the building into angular ones, thereby creating a dynamism in the image that is not inherent within the structure of the building as it stands.

Uniformity of detail

To enhance the clean, perfectionist quality of an architectural image – either interior or exterior – the building must present a uniform face. It is, therefore, essential to check for uniformity of the detail within the picture area (Figure 5.9). With office interiors, for example, this would mean setting all the blinds (typically the vertical Venetian variety) to appear at precisely the same angle of openness, and with none drawn aside. Office chairs should be either perfectly facing the desks, or perhaps angled invitingly towards the viewer. Chairs and blotter-pads around a boardroom table should be precisely arranged.

Figure 5.9 This canteen interior demonstrates the importance of uniformity of detail. The tables and chairs had to be neatly aligned to complement the clean perfection of the circular structure

For exterior photographs, all windows should be closed and any blinds or curtains consistently arranged. The lights inside should be switched on at every level both for the purpose of uniformity and also to give the building a lively appearance. The latter is obviously especially important for dusk shots (see Plate 6) where a single light left switched off could seriously spoil the final photograph. Similarly, a single window left open for a daylight shot can ruin the harmonious perfection of an elevation.

6

Understanding light, natural and photographic

Introduction

> Building forms, masses, voids and details are all revealed to us by
> light; without light we can only grope our way round them, and we
> cannot appreciate their spaces, proportions, scale or perspective
> without it. So the aesthetic of architecture depends greatly on the
> handling of light, which carries all the colours we can perceive.
>
> Paul Oliver and Richard Hayward,
> *Architecture: An Invitation* (Blackwell, 1990).

Our perceptions of how the world should look are dictated by the way we
have seen it illuminated by the sun, either directly or as diffuse daylight,
since the day we were born. Through all the years of human evolutionary
development, daylight has been the dominant source of light in everyday
life. We therefore subconsciously expect subjects to be illuminated either
from a diffuse overhead light source (as on cloudy days) or from a sharp,
direct source from an angle overhead (as on sunny days). Consequently,
studio photographers emulate these effects in controlled surroundings by
lighting still-life products with an overhead softbox; and portraits with a
direct light source from an angle overhead. Such lighting always produces
images we can readily understand and accept. A face lit from below rather
than from overhead can create an 'unnatural', horror portrait when
photographed, just because the direction of the lighting is opposite to that
which we naturally expect.

Natural daylight is the dominant light source used for most architectural
photography, both exterior and interior. Its effect can be modified by
placing filters over the camera lens for exterior work (as we have seen in
Chapter 4), or it can be supplemented with photographic lighting in order
to reduce the contrast of natural light in interiors.

As the dominant light source, natural light is the primary factor in the
complex practice of architectural photography. While aperture, shutter
speed, flash output etc. are all directly controlled by the photographer,
natural light remains under the exclusive control of Mother Nature. It is
this unpredictable factor that creates the interest, frustration and excitement

in the day-to-day practice of this type of work, and for which the architectural photographer must develop fundamental skills of timing and anticipation.

Natural light

The sun, 149 million km (93 million miles) from our planet earth, is the sole source of what we term 'natural light'. Sunlight is softened by the atmosphere: the envelope of gases, approximately 150 km (100 miles) deep, that surrounds the earth (Figure 6.1). The wavelengths of the different colours that comprise the sunlight are also scattered by the atmosphere. When a ray of sunlight meets an air molecule in the atmosphere, its colours are deviated, as in a prism. Each colour has a slightly different wavelength, red being the longest, through orange, yellow and green to blue and violet which are the shortest. The colours with the shortest wavelengths are affected the most. Consequently, more blue and violet is scattered towards us from air molecules all over the sky than any other colour, creating the blue sky we are familiar with on sunny days (our eyes are less sensitive to the violet). This blue sky acts merely as a reflector, and its effect is only realized in shadow areas. Sunlight is often further filtered and diffused by differing weather conditions such as cloud and mist.

Figure 6.1 Sunlight passing overhead is bent by air molecules in the Earth's atmosphere. The shortest wavelengths (blue and violet) are bent the most and therefore scattered towards us, creating the blue sky we are familiar with on sunny days

To us on earth, the sun appears to move across the sky from east to west reaching different heights depending on the latitude of the observer, the time of year and the time of day. The 'sun finder' charts in the Appendix at the end of the book enable us to find the sun's position at any specified time, at any location between the Arctic and Antarctic circles, on any day of the year. The colour of the light also varies between white 'photographic' daylight in the middle of the day, and deep red at dawn and dusk.

Weather forecasting

Since natural light is the primary factor in most architectural photographic assignments, an ability to forecast its behaviour and to plan a shooting

schedule is of paramount importance. This need not be as complicated as it sounds due to the excellent professional forecasting facilities available to us both on television for the national picture, and also over the telephone for localized forecasts in greater detail. In the UK, the 'Weathercall' information service supplied by the Met. Office offers detailed forecasting for 27 different areas up and down the country, as well as for the major cities around the world (Figure 6.2).

Figure 6.2 The 'Weathercall' telephone information service in the UK, supplied by the Met. Office is a useful source of localized weather forecasts

Our basic consideration for the purpose of architectural photography is to work out when the sun is going to shine, with clouds at a minimum. While a few fair weather cumulus clouds may yield the most attractive pictures, we must accept these only as a lucky bonus. We can get a general forecast from the television as to how the week ahead is likely to turn out, though detailed forecasting is rarely accurate much more than a day or two in advance. The way to gain the best understanding of current weather patterns is to monitor television weather reports and forecasts daily. I find the satellite photographs taken of the whole country particularly useful, as they show clearly where the cloud is lying at a particular time. When a consecutive sequence of these photographs is shown for different times, the direction of the wind and therefore the speed of the cloud movement become apparent. You can see, and estimate quite easily, whether or not cloud is developing or blowing in the direction of your location and if it is, approximately how long it will be before it reaches there. This is always summarized in symbolic form by the presenter and should confirm your own deductions. It is sensible to check the satellite photographs on the morning of your intended shoot, and if still uncertain of the days conditions, use the telephone 'Weathercall' information service for a detailed local forecast for your chosen location.

A useful instrument to help us understand the rhythm of changing weather patterns is a barometer. A barometer measures atmospheric pressure, giving us instant readings of pressure at all times. High pressure is often a sign of clear skies (hot in summer, and cold in winter); and low pressure usually signifies cloud and rain. Perhaps more significant for purposes of forecasting is the change in pressure that is taking place. Rapidly falling pressure suggests an oncoming depression with cloud and rain, while steadily rising pressure suggests fine weather for a few days. A

rapid increase followed by a drop in pressure is characteristic of changeable weather. In Europe, the dominant weather pattern consists of depressions moving from west to east.

These suggestions can be used as guidelines for developing your own personal system of weather prediction, or more specifically, sunshine prediction. Mistakes will inevitably be made both by the professional forecasters and yourself. It is the unfortunate nature of this type of work that there will be both wasted journeys, and other times when you have stayed back at base confident of bad weather from all the forecasts only to find clear blue skies and sunshine all day! Do not despair, however, as even on cloudy days a few rays of sunshine can break through. All the photographer needs is a few short bursts of sunshine to create a lasting impression on film.

The movement and angle of the sun

The job of the architectural photographer is to use the effect of direct sunshine on an elevation of a building to reveal texture, richness of colour and perspective through the interplay of the brightly lit areas with those in shadow.

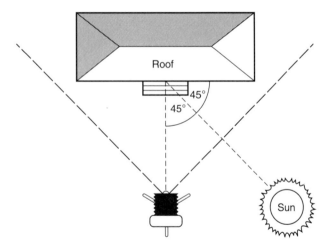

Figure 6.3 The optimum angle of the sun for straight-on elevation shots is 45°. Such top side-lighting is perfect both for modelling the structure and revealing its texture

The chosen angle of the sun can vary depending on the effect you wish to create. For example, extreme side-lighting on a multi-faceted building will emphasize its sculptural relief. However, the photography of most elevations demands less extreme lighting. For straight-on elevation shots, the best position for the sun is at approximately 45° between the axis of the lens and the plane of the elevation (see Figure 6.3). Such top side-lighting is perfect both for modelling the structure and revealing its texture. Even surface details will appear in strong relief as shadows (similar to studio lighting for portraits and product settings). For angled elevation shots, in order to show the solid structural form of a building, the axis of the lens should lie at approximately 90° to the angle of the sun, as shown in

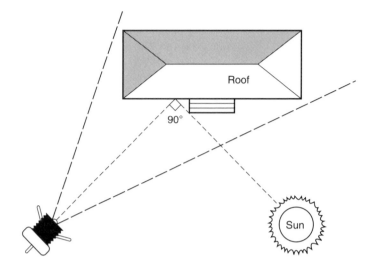

Figure 6.4 For angled elevation shots, the axis of the lens should lie at approximately 90° to the angle of the sun. The shadow cast across the visible side elevation emphasizes the solid structural form of the building

Figure 6.4. The front elevation of the building will be brightly lit with sufficient textural relief, while the visible side elevation will be in shadow. The contrast between the side in shadow and the front in full sun emphasizes its three-dimensional quality.

The smaller the angle between the axis of the lens and the direction of the sun, the lower the tonal contrast and therefore the flatter the appearance of the building on film, though the greater the visible detail on the side elevation, which can be extremely important. There is also a greater likelihood that the photographer's shadow will appear in the image. The

Figure 6.5 This simplified illustration demonstrates the movement of the sun around a building, marking the extreme positions of mid-summer and mid-winter. It shows us the likelihood of the sun shining on an assigned elevation according to its aspect

latter problem is most likely either early in the morning or late in the afternoon, and in the winter months, when the sun is at a lower elevation creating longer shadows. It can be overcome in one of three ways. First, you can disguise your shadow with that of a tree or building casting a shadow from behind you, if there is one. Second, it may be possible to use a vertical lens shift to reduce the foreground of the image in which your shadow appears; or third, you could either wait for the sun to move round or select an alternative angle with the sun in a more favourable position.

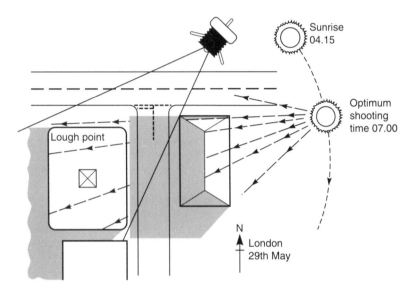

Figure 6.6 This is a practical example of critical timing for exterior photography. The optimum viewpoint to photograph 'Lough Point' was from a north-easterly direction, as shown. Being the end of May in the UK gave me a fine north-easterly sun with almost the highest elevation I could have hoped for. However, before 07.00 hours, the tall building opposite cast its shadow across part of the front elevation of 'Lough Point'. After 07.00 hours, the sun had moved round to throw the north, side elevation into complete shade. Fortunately, there was a period of about 5 minutes in which the shadow from the building opposite had cleared 'Lough Point' (see it still covering the pavement), and a glance of sunshine highlighted the two projecting sections on the north side of the building revealing, its form and texture

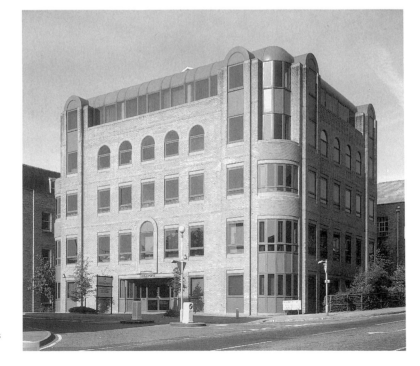

To make the most efficient use of the sun, work out the optimum time of day to shoot the relevant elevations using a map in the first instance, and a compass on site. Bear in mind that the sun rises approximately in the east and sets approximately in the west, as shown in Figure 6.5. In the UK in June, sunrise will be nearer northeast, and in December nearer southeast. Likewise, sunsets vary in direction from almost southwest in December to northwest in June. The precise angles and timings of the sun's position anywhere in the world can be deduced from the 'sun finder' charts in the Appendix at the end of the book. The sun reaches much higher elevations in the summer than the winter months with both advantageous and disadvantageous consequences for the architectural photographer. Exteriors are easiest to shoot in the summer months, with the higher elevation of the sun enabling it to penetrate even some of the most confined city streets (Figure 6.6). Any trees in view have foliage, adding a freshness and often a colour contrast to the image (especially with red-brick buildings). The light is whiter in summer, in photographic terms, and shadows shorter. The working day is longer, and blue skies more frequent, though there is a tendency for haze.

Conversely, in winter the light is redder in colour due to the extra scattering of light as a result of the greater distance it has to travel through the atmosphere. The lower elevation of the sun makes exterior photography more demanding, and timing all the more critical. However, it has a positive effect for interior photography, with shafts of golden sunlight penetrating much further into the rooms, as demonstrated in Figure 6.7. The extra warmth of this light adds a greater richness too. Clear blue skies in winter mean cold weather, and while fog is sometimes a possibility, the air is usually much clearer and crisper due to a lack of haze.

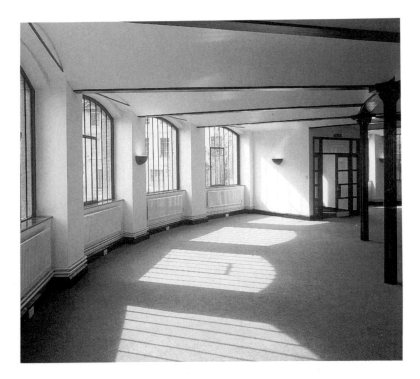

Figure 6.7 The lower elevation of the sun in winter can be a bonus for interior photography, creating shafts of warm sunlight that penetrate much further into rooms than in summer

The best seasons of all are probably spring and autumn with a compromise of the advantages and disadvantages of both the summer and winter months, and with an unsurpassed richness of natural colour in the foliage.

Calculating the optimum time of day for exterior photography

Working out the best time of day to shoot a particular elevation of a building, often the front, appears a simple task initially. We know that the sun rises approximately in the east, travels in a southerly arc to set approximately in the west. So far so good, and this will form the basis of our calculations. However, other factors can affect these calculations.

Prior to the day of the shoot, you need to obtain a location plan showing the geographical position of the building, and also a site plan if possible. These should be readily available, especially if your client is either an architect or property agent. All location and site plans work on a north-to-south, east-to-west grid system unless otherwise specified, in which case the direction of north will be shown. From the site plan, and with instructions from the client who is likely to be familiar with the building, you will be able to see the angle(s) of the main elevation(s) to be photographed.

Any partially south-facing elevation is guaranteed sunshine on a sunny day, unless completely dwarfed by tightly packed surrounding buildings. In principle, if the building faces south-east, plan to do your photography in the morning; and if it faces south-west, plan it for the afternoon. The more easterly the angle, the earlier will be the optimum shooting time; the more westerly the angle, the later will be the best time for photography. Buildings rarely lie perfectly due south, but when they do, judgement as to whether to photograph in the morning or afternoon may depend on the most important secondary elevation to be included in the shot.

This principle is broadly based on catching the sun shining frontally at your chosen elevation. Due to considerable variations in precise timings of the sun's movements throughout the year, this is the simplest principle to work by, even though the ideal angle of the sun to the elevation of the building is approximately 45° as outlined in the previous section. The variations however, mean that the elevation will rarely be precisely frontally lit by such rough calculations and is therefore more likely to be at a preferable slight angle. The photographer should aim to arrive early and can always wait for the angle to increase for improved texture and modelling, when necessary.

The principle works for most locations, most of the time. However, in confined city streets, tall buildings opposite your location can block out part of the sunshine when it is shining frontally at approximately 90° to your elevation. In such circumstances, I have discovered that if you choose the opposite time of day to that which you would normally calculate (for example, the afternoon rather than the morning) the sun will reach an angle that floods up the whole length of the street, first lighting up one side for half an hour or so (albeit at an oblique angle) and then the opposite side before disappearing behind the buildings once more (see Figure 6.8). If your building is in a confined street and faces south-east, for example, the best time to photograph its front elevation would be as the sun shines up the street in the afternoon and not in the morning as the principle would

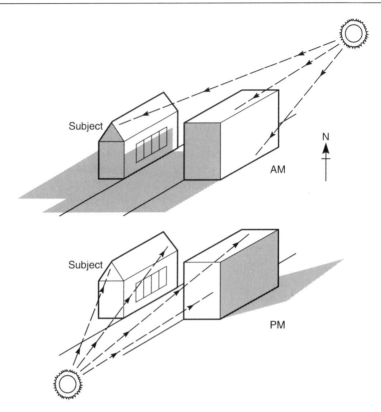

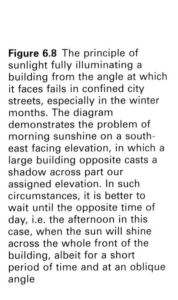

Figure 6.8 The principle of sunlight fully illuminating a building from the angle at which it faces fails in confined city streets, especially in the winter months. The diagram demonstrates the problem of morning sunshine on a south-east facing elevation, in which a large building opposite casts a shadow across part our assigned elevation. In such circumstances, it is better to wait until the opposite time of day, i.e. the afternoon in this case, when the sun will shine across the whole front of the building, albeit for a short period of time and at an oblique angle

suggest. Conversely, if your building faces south-west under such conditions, the best time to photograph it could well be in the morning.

North-facing buildings present their own problems, and are dealt with in detail in Chapter 8. Suffice to say here that it is sometimes possible to get sunshine on north-facing elevations in the height of summer, either very early in the morning for north-east facing buildings when the sun actually rises approximately in the north-east; or in the early evening for north-west facing buildings when the sun sets approximately in the north-west.

Finally, as mentioned earlier, do always carry a compass with you on location for calculating the sun's movement around the building when planning your shooting sequence for both exterior and interior shots.

The effect of clouds

In photographic terms, clouds can be seen as giant reflective filters, both diffusing the sun and skylight passing through them, and acting as massive reflector boards at the same time. The complete cloud cover of an overcast sky produces the softest light, reducing shadows and therefore contrast and texture of a building to a minimum. Images taken under such conditions appear dull and flat with an overall blue colour cast, unless corrected. The colour cast is the result of the mixed colour temperatures of the two light sources, the sun and skylight, raising the overall colour temperature of the light reaching the ground. It can be simply corrected using an 81-series filter, as discussed in Chapter 4.

With a clear blue sky, there is hardly any difference in brightness between the sky and the land or building that is the subject of your photograph, so long as the sun is at some angle behind you. In fact, with highly reflective white buildings, for example, a direct light reading taken from the blue sky will yield a much more accurate exposure reading for the building than anything you can take off the building itself. Consequently, blue skies appear on film as the rich blue skies they were in reality.

With an overcast sky, however, the cloud cover is the light source. Therefore, when it appears in the image, the contrast between the brightness of the cloud and the dullness of the building is so high that correct exposure for the building causes all detail of the clouds to be overexposed, or 'burnt-out', on film. The contrast can often be successfully reduced using a neutral graduated filter over the lens, revealing the attractive texture of the clouds.

While most architectural photography should be undertaken in sunny conditions where possible, overcast skies can be useful either when photographing some north-facing buildings, or those in confined spaces where the sun only manages to penetrate halfway down the building at the best of times. The contrast of a building cut in two by sunlight and shadow is difficult to correct successfully with graduated filters, so bright overcast conditions, colour corrected, will often yield the best results.

Variations in the colour temperature of natural light

Direct noon sunlight with a clear blue sky has a colour temperature of 5500 K, and is considered to be white, 'photographic' daylight. Because the sun is so much stronger than the brightness of the blue sky, the effect of the higher colour temperature of the blue sky is negligible in sunny areas. The effect of the light from the blue sky is realized only in open shade which is usually three or four stops darker, with a correspondingly blue colour cast.

The colour temperature of natural light varies up and down from this 5500 K base. The colour temperature of light from an overcast sky is higher, or bluer, at around 7000 K. An 81-series amber filter will reduce the colour temperature, as shown in Figure 4.2 in Chapter 4.

Nearer sunrise and sunset, the colour temperature of sunlight is much lower, or redder. Temperatures of around 4000 K are recorded two hours after sunrise and two hours before sunset. They can be easily corrected using an 80- or 82-series filter, though unfiltered 'warmer' images are often considered more natural and appealing. Precise correction of the colour temperature of any natural light can be achieved when desired through the use of a colour meter and a set of colour correction filters.

Lighting interiors

All interiors have their own individual combination of 'available' light sources, by which the naked eye views them. This is often a mixture of daylight through the windows, with some form of artificial lighting to supplement it: a ceiling light or table lamps, for example. This available light, especially the daylight, creates mood and atmosphere in the room and it is this that we want to convey on film.

However, the contrast between the light and shade areas in an interior, though readily discernible to the eye, is usually too great to record on film:

the light areas tend to 'burn out', and the shadow areas appear as black voids. The reason for this is that while the eye is sensitive to a range of at least 10 stops, colour transparency film only records about a five-stop range and colour negative film a seven-stop range.

In order to reduce the contrast, and thereby enable us to record the image clearly on film, we have to supplement the existing light with photographic lighting. Flash lighting, in the form of integral flash units mounted on stands and reflected off white umbrellas, is the most popular choice, as the colour temperature of the flash light approximates that of white 'photographic' daylight. It produces subtle diffuse lighting when used as a 'fill-in' source, preserving the atmosphere and interplay of light and shade in the room, while reducing the contrast to acceptable photographic levels.

The principle of 'fill-in' lighting

'Fill-in' lighting is secondary lighting for the sole purpose of reducing contrast in a photographic image. The available light in an interior remains the dominant source of illumination, while the diffuse fill-in light brightens the shadow areas just enough to be able to see some detail in them.

The precise angle of this fill-in light is not critical due to its diffuse nature. However, placed at an angle between the camera and the dominant light source (often a window), the gradual transition from light to shade is maintained, but the contrast subtly reduced. An angle closer to the camera, or even on the opposite side of the camera to the dominant light source, is usually acceptable, though tends to diminish the effect of atmospheric transition from light to shade. A fill-in light on the opposite side of the camera also runs the risk of creating its own conflicting set of shadows, thereby reducing its subtlety. A well-lit interior should give the viewer the impression that no extra photographic lighting has been added at all.

The strength of this fill-in light should be approximately one-quarter the power of the dominant light source. In other words, the reading taken off the furniture or floor of the strength of the available light should be two stops greater than the flash reading at a similar place.

Mixed lighting conditions

Problems arise in colour interior photography when the dominant available light is from a mixture of sources, often natural daylight and some form of artificial light source, typically tungsten or fluorescent. While tungsten lights can sometimes add a pleasing warmth to the photograph, unpleasant colour casts can be avoided on film by using a multiple exposure technique. Expose for each light source separately and use appropriate filtration over the camera lens to correct the colour of each source to the colour balance of the film in use. Use any fill-in flash during the daylight part of the exposure if there is one. A general rule for mixed lighting conditions is that the total exposure of a single film frame can be divided into as many parts as there are different types of light source in an interior, assuming that each source can be controlled independently of the others. For a fuller explanation of this technique, and for practical examples of fill-in lighting, please refer to *The Manual of Interior Photography*.

7
Technique and practical assignment

Introduction

The previous chapters have established the theoretical basis for determining when and how to shoot a series of photographs of a particular building. This chapter will concentrate on the practical day-to-day realities of architectural work, outlining various procedures for achieving successful results while minimizing the risks of failure.

Prior to the shoot

Careful pre-planning is the key to a successful shoot and the most efficient use of your time. You will have obtained in advance (where possible) both a location plan and a site plan of the building to be photographed (it is useful in this respect to have a fax machine to receive such material for immediate scrutiny and discussion with the client). From these you should be able to work out the optimum time of day for shooting the main elevation shots, using the theory outlined in Chapter 6. An advance reconnaissance trip with a compass and possibly a 35 mm camera is, of course, the very best option. However, the distances involved, and the economical use of your time often make this option unviable.

The most important, yet least predictable, factor in pre-planning is weather determination. You have to tailor your schedule around the good weather, and yet be prepared to change your plans at the last minute. The telephone weather services will give you an indication of the weather pattern over the next 4–5 days as a basis for your week's planning (see Figure 6.2 in Chapter 6 for the 'Weathercall' information service telephone numbers). Strive to make use of every sunny day for photography, and use the cloudy, dull days for administration and client visits. Always ask the client whether his or her priority for the photographs is speed of turnaround, or quality in terms of favourable weather conditions. Sometimes a client will need photographs at very short notice and will be prepared to accept results enhanced to the best of the photographer's ability under less than favourable weather conditions. The choice should always lie with the client, since he or she is the one paying your bill at the end of the day.

Finally, pre-planning also includes making sure that you have the appropriate and sufficient film stock, and that all your equipment is in working order with enough spare batteries and fuses to be able to cope with any such failure. This may seem obvious, but can be all too easily overlooked.

On arrival

When working in inner-city areas, it is often not possible to park your car at the premises that you will be photographing. In such circumstances either use a taxi to get you and your equipment to the location, or drive and use a local car park. If you choose the latter option, always drive to the site first, off-load your gear and then park the car. This saves you having to carry heavy equipment long distances, and arriving at the shoot exhausted.

If the weather conditions and angle of the sun are reasonable on arrival, waste no time in setting up the camera and shooting a few frames as quickly as possible. While architectural photography is supposed to be a slow, methodical and contemplative art, the practical reality is one of achieving results. There will, most probably, be plenty of time for contemplating the optimum viewpoint and patiently waiting for perfect light, but it is also quite possible that conditions will worsen. Clear blue skies can swiftly cloud over, and in urban areas large lorries with brightly coloured commercial logos emblazoned on their sides have an uncanny knack of parking directly in front of your building to unload heavy equipment for the rest of the day! Experience has trained me to always give myself the relaxed feeling of knowing I have got some adequate shots under my belt. If conditions worsen, it is usually possible still to continue the assignment by shooting the interior. Then at least you will have some acceptable results for the client, if not the best you could have achieved given abundant sunshine and perfect conditions.

In order to make the most economic use of your time and energy when shooting the interior of a commercial building, try to confine your work to a single floor (with the possible exception of reception and stairwell photographs). Often one floor is markedly better than the others: either the top floor with better light, or the ground floor with higher ceilings and larger windows making this a viable option. To work on a single floor saves the time-consuming and frustrating business of unpacking and packing all your equipment between shots.

A final word of caution when working alone in an empty building: never be tempted to use the lift. If you are photographing the building for a brochure, the lift is either likely to be new and therefore not yet 'run in', or it is likely to have been standing idle for a period of time. If you are alone and get stuck in the lift, it could be a long time before you are found. If there are two of you in the building, always travel in the lift one at a time just in case there is a problem.

Shooting sequence for exteriors

In order to explain thoroughly the practical shooting sequence for photographing the exterior of a building, I have broken it down into five stages: load the film; locate the perfect viewpoint; set up the camera; calculate correct exposure; insert and expose film. The chapter is

concluded with a separate section on 'Exposure determination', since this is the area most open to error, demanding experienced interpretation of meter readings for successful results.

Load the film

The method for film loading is obviously different depending on whether you are using sheet film for a large format camera, or roll film for medium format results. The principle, however, is similar in that the film must be successfully loaded without 'fogging' it. (A film is described as 'fogged' when it is accidentally and unknowingly partially exposed to ambient light.) With sheet film this is far more critical, as loading the unexposed sheet of film into the film holder requires either a completely light-tight changing bag or prior loading in a dark-room. With roll film, the unexposed film is covered with black paper and it is that paper that is slotted into the spool and wound on. While this provides the film with light-tight protection under moderate light conditions, direct sunshine can still cause fogging. Therefore, when working outside, always load and unload film in the shade, storing it back in its box or other darkened container until you get it to the laboratory. The boot of your car can often be a suitable place for loading and unloading films if it is parked close to where you are working. Never load or unload film in direct sunlight.

Locate the perfect viewpoint

Chapter 5 discussed the theories of composition and outlined some alternative vantage points for photographing the exterior of a building. Having decided the approximate angle from which you choose to start

(a)

(b)

Figure 7.1 Traditional architecture, as in image (a), tends to suit a normal or weak perspective, achieved with either a standard or long-focus lens; while modern architecture can often be more dramatically photographed with the strong perspective produced by a wide-angle lens – see image (b)

photographing it, you need to determine the optimum position from which a photograph will show off the building to its best advantage. Traditional architectural subjects tend to suit a normal or weak perspective, while modern architecture can often be dramatically photographed with the strong perspective produced by a wide-angle lens (Figure 7.1). Assuming you are using a view camera, use either your naked eye, or an appropriate independent optical finder to locate this position approximately. Restrictions of space may dictate a closer than ideal vantage point and the use of a wide-angle lens; or an interesting roof-scape may favour a more distant viewpoint, with either a standard or long-focus lens. Having located the approximate position, move around to the left, the right, higher and lower, a little closer and a little further away. In doing this you should be able to establish the perfect viewpoint that aesthetically juxtaposes both the foreground and background elements that comprise the setting of the building. Unless going for a completely symmetrical shot, select a vantage point from which the elements are juxtaposed asymmetrically, probably according to the Law of Thirds to some degree. Ensure there are no lamp-posts or other such vertical obstacles in awkward (or too perfect) alignment with an element of the building.

Set up the camera

Having established your vantage point, it is time to set up the camera on the tripod, aimed in the approximate direction of the building and with all the adjustment controls in their neutral positions. Next, level the camera either with the integral vertical and horizontal spirit-levels on a view camera, or with an independent or clip-on level on a SLR camera.

You then need to select the appropriate lens, often the longest lens capable of including the whole building within its setting from your chosen viewpoint. Dramatic impact shots will sometimes demand the use of a wide-angle lens, the camera position having been established by monitoring the effect either through an independent optical finder or by roughly viewing the scene through the camera itself from various positions.

With the camera and lens mounted in position, you need to roughly focus the lens. Then employ any desired camera movements, most often a rising shift with architectural exteriors to include the full height of the building while retaining perfect verticals. For final focusing once any movements have been applied, use a hand held lupe magnifier (typically x4 magnification) on the focusing screen of a view camera. Focus on the front elevation of the building and stop down the aperture to achieve the necessary depth of field. This can be done either visually (though at smaller apertures this can be awkward due to a progressively darker image on the viewing screen) or by using a universal depth of field table (see Table 7.1). For an angled shot of a receding terrace, a Scheimpflug adjustment is likely to be the best way of achieving perfect focus throughout the depth of the image as sharp focus is only necessary in one plane: that of the front elevation of the buildings.

The theory behind perfect focus throughout the depth of the subject being photographed is to establish the optimum plane of focus from which sharpness will extend in both directions to include the nearest and furthest elements of the picture, at a certain aperture. It is also important to find the largest aperture possible that will encompass this zone of sharpness, as the performance of even the best lenses tends to fall off at apertures smaller than $f/22$ due to diffraction.

Linhof Universal Depth of Field Table

Focus camera to far and near object points (also when Scheimpflug rule is applied) and measure extension difference in mm, using scale above. Look up this figure in appropriate format column and read off f/stop required to obtain the necessary depth-of-field on the same line at right. For intermediate values, use next smaller f/stop shown on the line below.

Set rear standard at half the displacement established

	2¼ x 2¾ in.	4 x 5 in.	5 x 7 in.	8 x 10 in.	f – stop
mm	1,2	1,6	2,4	3,2	8
mm	1,7	2,2	3,3	4,4	11
mm	2,4	3,2	4,8	6,4	16
mm	3,3	4,4	6,7	9,0	22
mm	4,8	6,4	9,6	12,8	32
mm	6,7	9,0	13,5	18,0	45
mm	9,6	12,8	19,2	25,6	64
mm	13,5	18,0	27,0	36,0	90
mm	19,2	25,6	38,5	51,2	125
mm	27,0	36,0	54,0	72,0	180
mm	38,5	51,2	77,0	102	250

Table 7.1 The 'Linhof Universal Depth of Field Table' calculates the minimum aperture needed to cover the required depth of field, once the optimum focus position has been established

In close-up work, the f-stop taken from the table should be corrected as follows:

G = 6 f : open by ½ stop; G = 2 f : open by 2 stops;
G = 4 f : open by ⅔ stop; G = 1.5 f : open by 3 stops;
G = 3 f : open by 1 stop; G = 1.3 f : open by 4 stops;

Explanation: G = distance of diaphragm plane to the forward ⅓ of the subject; 6 f = 6 x focal length of the lens employed.

The simplest way to do this is to measure the bellows displacement between the focus on the furthest and nearest elements of the image, and then set the camera to half the displacement measured. So first focus the camera on the furthest element and mark this position at the monorail, baseboard, or focusing knob. Then focus on the nearest element. The camera focus will increase and a second focus setting will be obtained. Measure the distance between the two displacements and set the camera at half this measured displacement. The optimum focus position for the desired depth of field zone has now been established. The corresponding working aperture needed to cover the required depth of field is found in the 'Linhof Universal Depth of Field Table' (Table 7.1). The appropriate minimum f-numbers for a given film format are listed for various bellows displacements. The table shows different displacements at the same aperture for different formats because smaller negatives normally require greater magnification. As a result, closer tolerances apply for calculating the depth of field available for critical sharpness. If neither the smallest possible aperture nor a Scheimpflug adjustment can produce sufficient depth of field to render the full depth of the image sharp, a smaller reproduction ratio has to be chosen by increasing the camera-to-subject distance or using a lens of shorter focal length.

Having set the focus you can now place any appropriate filters over the camera lens, not forgetting to take into account their exposure factors when calculating exposure. At this stage, scrutinize the picture area for any rubbish, unsightly bins, orange cones etc. that will detract from the perfect appearance of the building, and remove them accordingly for the duration

of your photography. Even a small piece of white paper can be easily overlooked when taking the photograph, yet can leave an unsightly scar on the film.

Calculate correct exposure

The different methods for determining exposure are outlined at the end of this chapter in a separate section: 'Exposure determination'. Following one of these methods, work out the correct exposure for your choice of film and decide upon the best combination of aperture and shutter speed to take account of optimum lens performance, depth of field, and any movement in the image.

Re-check the focus, levels and composition. Also, make a mental note of the boundaries of the image on the viewing screen (on a view camera) to avoid uncertainty over whether any pedestrian or motor traffic will be appearing in the shot once the shutter is closed and direct viewing is impossible. Then close the shutter and set the aperture and shutter speed.

Insert and expose film

Insert the film holder into the back of the camera (on large format), or replace the focusing screen with a film back (on medium format). It is sensible to always start with instant-print film both as an exposure indicator and, more importantly, as an invaluable way to check the composition. On some medium format cameras, the area of instant-print film exposed can be greater than the area of the viewing screen. If this is the case, carry a black card mounting mask with you for laying over the instant-print in order to show the parameters of the actual image that will appear on the subsequent negative or transparency film.

Instant-print film will also show the approximate effect of filtration, and will confirm whether or not any vignetting of the image is taking place (Figure 7.2) as a result of excessive shift movements (the latter can be difficult to check visually with confidence on the focusing screen). If there is vignetting of the image, the various techniques to overcome this problem are outlined in the section: 'Tall buildings' in Chapter 8.

When working in direct sunlight it is sensible to leave the dark cloth draped over the back of the camera, covering the film holder to prevent the possibility of any light leak. Always remove the dark slide slowly and steadily to avoid displacing the precise camera position with any jerking movements. Expose the film, always using a cable release. Squeeze the cable release gently, again to prevent any jerking movement that could possibly shake the camera at that critical moment of exposure.

When satisfied with the instant-print image, you can shoot the transparency or negative film. On colour transparency roll film especially, it is sensible to bracket the exposures in half-stops to at least one stop either side of your predetermined exposure calculation to guarantee a correctly exposed image on film. With sheet film, it is customary to shoot at least one, and preferably two back-up exposures. This enables the first to be processed normally, and the processing of the second and third to be 'pushed' (the lengthening of the film development time if the first sheet was under-exposed) or 'pulled' (the shortening of the film development time if the first sheet was over-exposed) accordingly for perfect results. Push- or pull-processing of transparency film by up to one stop should

Figure 7.2 Use an instant print to check composition and the approximate effect of filtration. If the area of instant print exposed is greater than the area of the viewing screen, lay a black card mask over the instant print to check for any vignetting of the image as a result of an excessive shift movement

yield excellent results, correcting exposure within what is effectively a two-stop band. Wider than this, contrast is reduced as a result of pull-processing with colours shifting towards blue. Conversely, with push-processing, contrast is increased along with graininess and fog levels, and colours shift towards red. Shooting two spare sheets virtually guarantees a perfect image for the client, and should enable you to keep a perfect original for your portfolio or archives.

After exposing the film, remove the film holder or film back and replace the focusing screen. Open the shutter to its widest aperture to re-check composition and focus, and confirm in your own mind that the tripod has not been inadvertently jolted off position in the picture-taking process.

Finally, carefully pack away your equipment after finishing the shoot. Replace all lens caps, return filters to their cases, and put meters back in their pouches etc. If you treat your expensive equipment with the greatest respect it should serve you well for many years.

Exposure determination

An exposure reading is used to determine the appropriate combination of lens aperture and shutter speed necessary for a favourable recording of a subject on film (of predetermined speed). There are basically two alternative types of reading: direct reflected readings or incident light

readings. A direct reflected reading measures the brightness, or luminance, of the light being reflected off a building (as with the metering systems in most SLR cameras); while an incident reading is taken from the subject with the meter pointed towards the camera, to measure the intensity of the light falling on the building.

Either method is appropriate for architectural work, though both require careful interpretation of the metered results to calculate the correct exposure for the specific building being photographed. This is because all meters work to a standard of average brightness and are designed to give a correct exposure reading for a perfect mid-grey subject, based on the Kodak 18% grey card. However, different building materials absorb and reflect different proportions of the light illuminating them, causing erroneous readings. For example, if a photograph was taken of a white wall using a direct reflected reading alone, the result would be a mid-grey toned wall on the final photograph. To render the tone of the white wall as white in the photograph, a 2–2½ stop increase in exposure over the meter reading would be needed. Table 7.2 outlines some typical sources of exposure error with the exposure increase or decrease necessary to correct such erroneous readings.

An incident reading of the same subject should yield a correct result on film as it measures only the intensity of the light irrespective of the subject matter. The white plastic diffusing dome placed over the meter for such readings transmits 18% of the light: the mid-tone point between black and white. Consequently, setting the camera from an incident reading preserves whites as brighter than average and blacks as darker than average. However, it ignores any areas in shadow. Accordingly, incident readings meter for highlights, which are your main priority when shooting on transparency materials. A rule of thumb is to expose transparency film to preserve the highlights and lose the shadow detail (to prevent the highlights from 'burning out'); and to expose negative materials to preserve the shadow detail (most easily achieved using direct reflected readings).

The reason for this sacrifice of either highlight or shadow detail is due to the limited sensitivity of photographic film. The range of brightness from white to black on a sunny day can be up to 10 stops. However, negative film (both colour and black-and-white) can only record a seven-stop range, and colour transparency film a mere five-stop range.

While direct reflected readings are more susceptible to subject error than incident readings, their strength lies in allowing the photographer to take a series of readings from different elements of the subject area to gain an overall impression of the range of brightness in the image. These readings

Table 7.2 Sources of exposure error. All light meters work to a standard of average brightness and are designed to give a correct exposure reading for a perfect mid-grey subject. Because different building materials absorb and reflect different proportions of the light illuminating them, adjustments have to be made to the meter readings accordingly

Subject	Meter-reading adjustment
Freshly painted white buildings; sunlit snow	+ 2 stops
Weathered white buildings; new plaster; pale grey sky	+ 1 stop
Red brickwork; green grass; blue sky; dark grey sky	No adjustment
Dark glass buildings; dark timber; dark green foliage	– 1 stop

can be taken with a regular hand-held lightmeter; with the metering system of a 35 mm camera; or with a spotmeter (1° angle of view) for precise light readings, especially when using a long-focus lens, from very specific parts of the larger picture area. Some large format cameras also have the facility for add-on probe meters which take spot readings from small selected areas of the subject image on the focusing screen. Such readings also take account of any filtration being used.

When taking reflected readings, try to take them off approximate mid-grey subjects. From Table 7.2 you can see that red brickwork, green grass and the deep blue of a clear sky (roughly 180° from the sun) conveniently approximate mid-grey for the purposes of architectural photography. Alternatively, you can carry a Kodak grey card with you and take your light readings off that under the same light conditions. When photographing buildings, it is the sunlit part that you should usually expose for, especially on transparency film.

For large format black-and-white photography, the 'zone system' for exposure is probably the ideal method for deducing perfect exposure. Devised by American landscape photographer Ansel Adams, the zone system is a method for controlling the tone range of the final print. The image is previsualized into nine tone zones which can be adjusted by changes in exposure and development. A detailed analysis of the zone system is beyond the scope of this book, but it is well documented in books on photographic theory.

In case of meter failure, it is possible to estimate exposure by using the 'Sunny-16' rule due to the relatively consistent intensity of bright sunlight in moderate latitudes. The rule states that if you set the aperture to $f/16$, the correct shutter speed is roughly the inverse proportion of the film speed. For example, working with ISO 100 colour transparency film with full sunshine on the front elevation of a building, at an $f/16$ aperture, the estimated shutter speed for correct exposure would be 1/100 second, or 1/125 being the closest approximation on most lenses. In hazy sun allow one extra stop; light cloud, two stops; and under heavily overcast conditions, three stops. On roll film, always bracket the exposure in half-stops by at least one stop either side of the determined exposure.

All light readings are measured in either exposure values (EVs) and/or the appropriate combination of lens aperture and shutter speed for a particular film speed. Exposure values are numbers that stand for a particular amount of exposure that can be achieved using a range of equivalent combinations of aperture and shutter speed in accordance with the Law of Reciprocity. They are widely used on hand-held light meters to determine the range of aperture/shutter speed combinations possible to accommodate a particular EV number. Having deduced the EV number, you next have to choose the appropriate combination of aperture and shutter speed to achieve the best results on film. The ideal compromise between lens aberration distortion and diffraction for optimum lens performance is typically between $f/16$ and $f/22$, though this can be checked with the lens manufacturers. Because most architectural subjects are static, other than tree movement and sometimes people or traffic, slow shutter speeds can be used even on relatively slow films to enable the use of apertures for optimum lens performance. For example, shooting on ISO 100 film in bright sunshine, the aperture would be approximately $f/19$ at 1/60 second. This would be an ideal combination, assuming satisfactory depth-of-field within the image. Otherwise a

smaller aperture and slower shutter speed could be selected. On a cloudy day, a typical combination could be f/16 at 1/15 second on ISO 100 film, again suitable for optimum lens performance and still a reasonable shutter speed for most architectural subjects. Be wary of using exposures longer than this in windy conditions for fear of camera shake from the wind. Under such conditions, wait to make your exposures in the lulls between gusts.

8
Problem exteriors

Introduction

Much of the theory outlined so far assumes the subject matter of architectural photography is well-proportioned buildings standing in their own grounds on a sunny day, with their main elevations varying in orientation within a southerly aspect. Such an assumption is necessary for outlining the underlying principles as a basis for this type of work. However, while many buildings do fall into this category, others inevitably do not in the day-to-day reality of practical assignments. Buildings with north-facing main elevations exist, as do extremely tall buildings and long, low buildings. Space can be severely restricted in narrow city streets, for example, and unsightly obstructions, including parked vehicles, can spoil the view. A combination of any of these conditions can make life very challenging for the photographer, especially if pressure of time demands the work to be undertaken in unfavourable weather conditions. The purpose of this chapter is to offer practical solutions to all of these problems, accepting that the photography of some awkward buildings must be the best possible compromise under the prevailing conditions.

Poor weather conditions

When speed of results is the client's only priority the photographer is sometimes left with no choice but to try and achieve satisfactory results in less than ideal weather conditions. Assuming the sky is grey and overcast, you can use a pale amber 81-series filter (typically 81B) to warm-up the cool colours of a dull day on colour film, combined of course with a longer exposure than on a sunny day. A graduated blue filter will add a hint of blue to the overcast sky, while reducing the contrast between the cloud cover and the building. A relatively strong graduated filter is recommended when used in conjunction with an 81-series filter not just for contrast reduction but also to retain some of the blueness from the graduated filter on film. Because the colours amber and blue neutralize each other in effect, a stronger blue is necessary to prevent the graduation effect appearing similar to that of a graduated neutral density filter.

An alternative in situations of adverse weather conditions is to shoot the building at dusk, with lights glowing from all the windows – see section: 'Night shots' in Chapter 9. The beauty of this alternative is that as the sky darkens, its appearance on film is deep blue even in overcast conditions.

I would not recommend any work to be undertaken in the rain. Other than in exceptional circumstances, there will usually be sufficient breaks between showers when the sky actually brightens in which to take any photographs.

North-facing buildings

North-facing buildings are probably the toughest challenge for architectural photographers. It is possible for either the rising or setting sun to illuminate the front of a north-facing building (in an open area) in the mid-summer months, with ever-increasing likelihood the greater the angle of the face of the building toward north-east or north-west. This is because in mid-summer, the sun actually rises in the north-east and sets in the north-west at moderate latitudes, as discussed in Chapter 6. If a building faces north-east or north-west, it should catch some of the sun in the morning or late afternoon for most of the year, as demonstrated in Figure 8.1.

However, with buildings that are genuinely north-facing, with little angling to the east or west, the practical reality is likely to be that no sun strikes the building at the time of year that you have been asked to photograph it. Assuming this to be the case, the rest of this section outlines various ways to achieve satisfactory results from such unfavourable circumstances.

If the building to be photographed is situated in a street, it can sometimes be quite brightly illuminated by reflected sunlight off the building opposite.

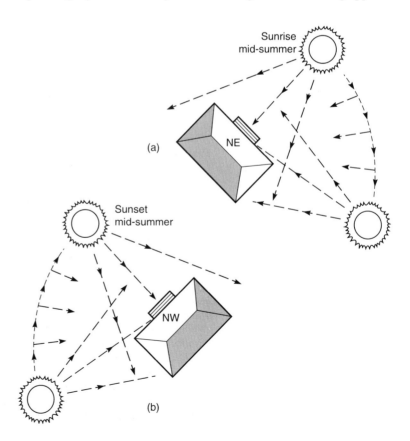

Figure 8.1 In the northern hemisphere, north-facing buildings will be illuminated by the sun in the summer months, with increasing likelihood throughout the rest of the year the greater the angle of the face of the building toward north-east or north-west

When this is the case, make sure the camera is angled to the building in such a way as to avoid photographing toward the sun. From such an angle it should also be possible to retain a sufficiently blue sky above the building, though this can be supplemented if necessary with a graduated blue filter.

Where the building to be photographed cannot benefit from either direct or reflected sunshine it is best to shoot it under bright overcast conditions. This avoids having the front elevation of the building lost in deep shadow on a sunny day, and also avoids the possibility of having to photograph directly into the sun. Under such bright overcast conditions, the front elevation should be evenly lit, though flat in contrast. Use a graduated blue filter, or selective filtering, to redress the colour of the sky. Again, an 81-series filter can be used to warm the colours of the building, though bear in mind that this will diminish the blue colour of the graduated filter. In these circumstances it may be necessary to use a relatively strong graduated filter to compensate for this.

As with poor weather conditions, a successful alternative could be to photograph the building at dusk as a night shot (see section: 'Night shots' in Chapter 9).

Tall buildings

A tall building photographed from ground level, using an extreme rising shift to retain perfect verticals in the subject, can appear top-heavy with verticals apparently diverging (as shown in Figure 2.6 in Chapter 2). The reason for this is that the outermost part of the field of view actually becomes elongated owing to geometrical distortion in the image when subjected to extreme shift movements. Therefore, tall buildings are most effectively shot from a vantage point approximately a third the height of the building being photographed (Figure 8.2). Too high a vantage point will diminish the stature of the building, so to photograph it from a third of its height produces an image with reasonable perspective that also retains its stature. Where it is impossible to find a suitable vantage point above ground level, the most effective solution is to tilt the camera slightly and use less of the shift movement, even though this contradicts the basic theory of architectural photography to retain parallel verticals at all costs.

The best way to do this is to start by tilting the whole camera to include the full height of the building, as with a fixed plane camera. Then correct the converging lines by tilting the lens and image standards to a vertical position. This has the added advantages of both overcoming shift restrictions when using long bellows extensions and keeps both standards close to the rails for optimum stability. A rule of thumb when photographing tall buildings is that when the standards need to be tilted more than 20° to restore their verticality, some under-correction is likely to improve the image. A suggested guide is that the rear image standard should be tilted off vertical again by half the tilt over 20°. For example, if the standards need to be tilted 30° to restore perfect verticality, the rear standard should be tilted back to 25°, 5° off vertical (30° − 20° = 10°; 10°/2 = 5°).

Tilting the camera slightly, or choosing a vantage point above ground level not only enhances the perspective of the building in the image but also overcomes the use of an excessive rising shift movement to include its

Figure 8.2 A tall building is most effectively photographed from a position approximately a third of its height, to avoid the problem of geometrical distortion in the image as a result of an extreme rising shift movement. This photograph was taken from the top of a fire-escape on a suitably located building opposite

full height in the picture. Apart from the the potential problem of geometrical distortion when using extreme shift movements, the more serious problem of excessive shift is that of vignetting: the situation when the shifted image reaches the outer limits of the circle of illumination causing the corners of the image to blur into a dark vignette. There are, however, other solutions to this problem. If space permits, you could move further away from the building to decrease the size of the building in the image. If that is impractical you could select a wider lens which will have the effect of reducing the building size without changing the perspective as long as the camera position remains the same.

It is also possible to overcome the problem of vignetting by using a little backwards tilt on the front of the camera to move the centre of the image circle down towards the centre of the film area. However, this will cause the top and bottom of the image to go out of focus due to a shift in the plane of focus. To counteract this, you can stop down the lens further to increase the depth of field in the image. A final alternative solution, if prints are to be the end product of the shoot, is to shade the vignetted corners when printing.

A further problem with tall buildings in confined city streets is the difference in brightness between the top and bottom of the building. This is not a problem if direct sunshine fully illuminates both the top and bottom of the building, but presents a serious problem when the top portion of the building is in bright sunshine, and the bottom of the building is in deep shadow. The problem is likely to be most apparent in the winter months when the sun is lower in the sky. A graduated neutral density filter (with the

shaded area at the bottom) can reduce the effect to an extent, though never completely. A graduated neutral density filter is most useful in hazy or overcast conditions when the top of a city building can still be over a stop brighter than at the bottom. Because the transition from brighter to darker is gradual (rather than abrupt in direct sunlight), a graduated neutral density filter can be subtly employed to redress this balance.

Finally, if a suitable vantage point is difficult to locate within a confined city area, look around for suitable tall blocks that can be viewed from a third of the way up the building itself. It should be clear as to which of these blocks are likely to offer a vantage point with an unobstructed view of the building within its cityscape.

Long, low buildings

The buildings that comprise modern industrial and retail parks are frequently long and low in structure, intrinsically uninspiring and difficult to photograph with much creative impulse. There are basically three alternative approaches one can adopt: to photograph them within their landscape; to photograph them at an oblique angle from close-up with a wide-angle lens to inject some exciting line dynamics into the structure; or if you are lucky enough to find a high vantage point overlooking a corner of the site, you can take some interesting low-level aerial shots.

By photographing a long, low building from a distance it is sometimes possible to create an image that utilizes the surrounding landscape to generate either interest or dynamic structure (Figure 8.3). For example, the front elevation of the building could be photographed with a wide-angle lens from a head-on position, with the full width of the building on the horizon just above the central horizontal line on the viewing screen. A clean blue sky would fill the top third of the image, and the dynamic structure of the image could be created by receding lines in the expanded foreground. These could simply be the white lines marking parking spaces,

Figure 8.3 Long, low buildings are difficult to photograph effectively. This one was shot from a slightly heightened vantage point to show the building within its setting

the lines of a path, a row of trees, or even cars themselves. Alternatively, the building could be placed a little below the central horizontal line on the viewing screen, with the drama in the image coming from an exaggerated blue sky.

To photograph the building at an oblique angle with a wide-angle lens, one is successfully injecting some exciting line dynamics that do not inherently exist within the structure of the building itself. Depending on the usage of the photographs, such a shot may not be acceptable as it does not include the full front elevation of the building. However, it can be useful when used in conjunction with one of the other alternatives.

Some sort of low-level aerial location with a vantage point overlooking the corner of the site can often produce the most favourable results with this type of building. The line dynamics within the image structure are created by looking down on the building from an angle. The area of the image taken up by the building itself is expanded by including some of its roof, which also shows off the three-dimensional nature of the structure. It also gives the viewer a better understanding of the scale of the site as a whole.

Restricted space in narrow streets

Architectural photographers working in cities or towns are often physically restricted from selecting the ideal viewpoint by the surrounding buildings. A large building in a relatively narrow street demands the use of a very wide-angle lens from an oblique vantage point. The focal length of the lens tends to be dictated by the size of the building within the restricted space. The shorter the focal length, the less oblique the camera-to-building angle need be, but the greater the perspective exaggeration.

Using a view camera, a way to reduce the effects of both the obliqueness of the camera angle and the corresponding perspective exaggeration is to angle the camera less obliquely to the building, with the image of the building now appearing half-on, and half-off the viewing screen. You then need to employ a cross shift movement of either the front or rear standard to return the full width of the image of the building to the focusing screen. The resultant image has a somewhat flattened perpective, thereby expanding the area of the front elevation that is visible through the lens – see Figure 2.5, in Chapter 2.

Parked vehicles and other obstructions

Where there are parked cars outside the building to be photographed, that are not easily moved, the simplest solution is to shoot over the top of them either by extending the height of the tripod and standing on a step-ladder, or by finding a higher vantage point, possibly a window, fire-escape or even the roof of a suitably situated building opposite.

Alternatively, in situations where the building is set back from the street by a wide pavement, it is sometimes possible to photograph the front elevation with a wide-angle lens from an oblique angle that actually keeps any parked vehicles out of view altogether.

It is also occasionally possible to use parked cars for creative effect by deliberately including in the foreground of the image a reflection of the building in the windscreen or shiny paintwork of one of the cars itself.

When there is no suitable alternative other than to include some cars in the photograph, do try and ensure that any in the foreground are clean and new. Also avoid showing registration plates as they are both an unnecessary visual distraction and quickly date the images.

Finally, when photographing the exterior of a building across a busy street, there will almost always be momentary clear breaks in the traffic in which to take your shots. Patiently wait for these moments, or select a higher vantage point from which to shoot above the traffic.

Construction sites

Architectural photographers can be called upon to photograph the developmental progress of a building from construction through to completion. While the general approach to photographing construction sites remains the same as for completed buildings, several extra factors are involved.

General progress shots of the whole site, updated at regular intervals, should where possible be taken from exactly the same spot with the same lens, and with the subject matter precisely within the same parameters on the focusing screen on each occasion. Selecting the perfect vantage point requires careful forethought and preplanning in consultation with the architect as to the scale and precise positioning of the building to be constructed. The roof of one of the site huts can sometimes provide such

Figure 8.4 Foreground action animates construction site photographs

a perfect view point, as they are usually well positioned for an overview of the site, and provide an undisturbed semi-aerial platform that will remain in place until completion of the project. It is also possible to mark the precise positions of the tripod feet with paint for future use. Remember to note the height of the tripod (e.g. tripod legs fully extended, but with no extension of the central column), the lens used, the extent of any shift movements employed, and the parameters of the site on the viewing screen.

Close-up shots are likely to be more abstract in nature, due to the abstract shapes of both the materials and the skeletal structure of a building under construction. This is largely inevitable in order to create aesthetically attractive images from a messy, muddy and material-strewn site. All construction site shots are more interesting for the viewer if the subject matter is animated, i.e. with some foreground construction action to dramatize an image of a busy site with development actually in progress (Figure 8.4).

A final word of caution: building sites are muddy, dusty places so remember to wear appropriate clothing, especially on your feet, and to keep your equipment protected from the dust as much as possible when not in use. This means keeping the camera in a closed carrying case when not mounted on the tripod, and covering it over with your black viewing cloth (assuming a view camera) when mounted between shots.

Shopping centres and retail sites

The purpose of architectural photography is to convey an advantageous impression of primarily the structure, but also the function, of a building through a combination of creative viewpoint and technical excellence (perfect verticals, sharp focus throughout the depth of the image etc.). This is equally true when photographing shopping centres, or aspects of them, for architect clients. However, much of the commissioned photography of shopping centres and retail sites is for purposes of marketing those sites to potential retailers. Because of this, the usually fundamental requirement of technical excellence (to reproduce best the structure of the architecture on film) becomes secondary to the function of the building: the creation of an atmosphere of thriving and successful trading within the attractive setting of the centre. This, basically, means filling the frame with plenty of attractive people laden with shopping, along with as much signage of major national retail chains as possible. The focus of attention becomes primarily the activity itself, within the setting of the centre. This is likely to restrict such work to Saturdays, especially from lunchtime through the afternoon.

In such circumstances, it is sensible to abandon the view camera in favour of a roll film SLR to enable you to view the busy action directly through the view-finder till the precise moment of exposure in order to maximize the number of suitable shoppers, aesthetically juxtaposed, within the frame. 'Suitable shoppers' are those that look like they would be regularly spending plenty of money: well-dressed young and middle-aged couples, suited men and women, and parents with a child in a buggy. The use of a SLR also allows one greater spontaneity in capturing action as it unfolds. Always spend a while wandering round the centre first without the camera, looking for active thoroughfares and working out approximate settings that would both include plenty of people and appropriate signage (Figure 8.5).

Figure 8.5 When photographing a shopping centre for a marketing brochure, a combination of fill-in flash and long exposure (between 1/15 s and 1 s) at a busy time creates a semi-sharp blur of activity within the static setting. Always include the signage of major national retailers

Most of the activity around shopping centres is within the centre itself, so while inevitably some shots will be required of the front exterior, the bulk of the work will be inside. Often the centres are lit with a combination of daylight through skylights and some form of artificial lighting which can be quite adequate for general view internal shots. For more detailed shots, fill-in flash from a portable flashgun is essential. Always use a tripod, and I would advise the use of a regular slow/medium-speed daylight-balanced transparency film rated at ISO 100 for colour work, and a similarly rated film for black-and-white work. This may seem a strange choice in a situation of relatively low-level lighting when a faster film would appear the more natural option, but it does actually have the perfect attributes for this type of work, as I shall explain.

First, a slower film, with its smaller grain size, will always yield a higher quality image than is possible with a faster film. Second, and more specifically for this type of usage, the combination of fill-in flash with a necessarily long exposure creates a semi-sharp blur of activity within a static setting. This is the best possible way of showing genuine activity within the specified structure. The flash freezes a semi-sharp outline of the people, and the exposure of between 1/15 and 1 second for the ambient light blurs their subsequent movement. The use of flash also helps to counteract any undesirable colour casts from artificial light sources that would otherwise need to be filtered out. Test shots on instant-print film will give a good indication of the likely effect to be achieved at different shutter speeds, though no action of this nature is ever exactly the same twice.

Another way of creating the impression of a busy, densely packed shopping centre is to use a long-focus lens, typically a 180 mm lens on medium format. Long-focus lenses have the effect of flattening perspective, thereby compressing people in the foreground, middle-ground

and background into an apparently unified group. By using a relatively modest long-focus lens, a realistic depth of field can be maintained in order to show some of the structure and valuable shop signage in the background, without rendering it all to an out-of-focus blur. The flattened perspective that is created actually increases the scale and dominance of any background signage.

The use of a long-focus lens can also be used to good effect at an outdoor retail site to flatten the perspective in an image of the unit with a foreground car park. A less-than-full car park can be strategically photographed with a long-focus lens with the effect of compressing the cars that are there into a unified group. Other suggestions for creatively photographing retail park units are outlined in the section: 'Long, low buildings' earlier in this chapter.

9
Creative techniques

Introduction

This book has so far been concerned with the basic techniques and underlying principles of architectural photography, and their practical application in both straightforward and problematic situations. The purpose of this chapter is to expand this range of techniques in order to enhance the creative impact of your architectural images. This can be achieved in a diversity of ways, ranging from the use of simple camera movements for creative composition, to the use of specialist films, cameras or lenses for special effects. All the techniques are valid occasionally, and often as supplementary shots to the more conventional ones.

Deliberate convergence of verticals

Contrary to the golden guiding principle in architectural photography for perfectly parallel verticals, there are occasions when the deliberate convergence of verticals successfully boosts the dynamic impact of a shot. To do it deliberately, it must be extreme, with the camera at a sharp angle, in order to maximize the angles of the diagonals. With anything less than extreme you could run the risk of the image appearing as if parallel verticals had been poorly attempted with a rigid, fixed plane camera.

These deliberate convergence photographs can be divided into two types. First, there is the symmetrical shot of a basically symmetrical front elevation, as in the cover photograph. The line of the base of the film plane must be parallel with the wall, a low viewpoint selected (often as low as the tripod will allow), and the camera tilted to include the full height of the front elevation. The use of a wide-angle lens maximizes the dramatic effect, producing the dynamic diagonals that result from selecting a close viewpoint. As with any symmetrical shot, precision alignment is the essential criterion for an outstanding result.

The second type of deliberate convergence photograph is reserved for the high-rise block to dramatize a subject that can otherwise be, as its name suggests, an uninspiring rectangular block (Figure 9.1). Standing quite close to its base, you tilt the camera almost on its back to look up at the top corner of the building, using either a standard or wide-angle lens. The dramatic linear perspective emphasizes the height and presence of the building, creating an exciting image.

Figure 9.1 This is an example of a deliberate convergence shot to dramatize a high-rise block. The resulting dynamic perspective emphasizes the height of the building in an exciting way

One final word of caution: do not attempt a deliberate corner convergence shot on a building with a front elevation that is wider than it is tall as this is likely to produce an image in which the building appears uncomfortably as though it is both falling over backwards and in on itself at the same time (see Figure 2.3 in Chapter 2). Reserve the technique for tall buildings only.

Tilting the camera

A second way of creating impact in an image is by converting both the vertical and horizontal lines of a building into diagonal ones by tilting the camera at an angle on its side (Figure 9.2). The effect is exciting, though somewhat disorientating as we do not expect to see buildings on anything other than level ground. Such a technique can be useful for abstract detail shots, and only rarely for full building shots, but their use should be restricted to a subject that has little intrinsic dynamism of its own. The whole exercise should be treated as a creative process of abstract picture composition.

Expanding the sky area with shift

A simple technique that appears to isolate a building within a significant setting is to take a portrait shot of a basically horizontal building. Then employ an excessive rising-front shift movement on the camera to place the building close to the bottom of the frame (while retaining perfect verticals). This has the effect of filling the rest of the frame with a large area of blue

Figure 9.2 Tilting the camera at an angle on its side converts the vertical and horizontal lines of a building into diagonal ones, for dynamic effect

sky, as in Plate 5. With an excessive shift movement such as this, the blue of the sky will tend to darken towards the top of the frame as the limit of the lens's circle of illumination is approached. This subtle darkening only serves to enhance the image, and if further darkening is desired, a neutral density graduated filter can also be successfully employed. This technique works best when the colour or tone of the building contrasts strongly with the colour or tone of the sky.

Correction of horizontal convergence in interiors and exteriors

As we have seen throughout this book, architects like to see perfect vertical lines in the images of their buildings, easily achieved through the use of a simple rising-front shift movement in most cases. In this section we will consider the possibilities and implications of perfecting the horizontal lines in an image as well.

With the camera at an angle to the opposite wall in an interior, convergence of the horizontal lines of the floor and ceiling is the inevitable result. While this is much more visually acceptable than vertical convergence in an exterior shot of a building, it can still be corrected when necessary to satisfy the exacting demands of the architect. In order to achieve this, the film plane must be parallel with the plane of the opposite wall and a cross-front shift movement employed to re-capture the view of the interior, but with fully corrected horizontal lines – see Figure 9.3.

The same technique can be usefully exploited with exteriors to achieve different objectives. The first is when the viewpoint is restricted for a direct, front-on elevation shot (by an obstruction such as a street sign or busy road) and no perfectly central viewpoint is possible. A viewpoint slightly to one side can be adopted with the film plane parallel to the

(a)

Figure 9.3 Image (a) shows a
typical commercial interior
photographed for a property
brochure, with natural
convergence of the horizontal
lines in the image. Image (b)
shows the same interior but
with the horizontal convergence
corrected by employing a cross-
front shift movement on a view
camera. Such clean parallel lines
would be more appropriate for
the exacting demands of an
architectural client

(b)

elevation of the building, and a cross-front shift movement utilized to re-
centre the image on the viewing screen while retaining parallel horizontals
and verticals.

The second use of such cross-front shift movements for exterior work is
to deliberately add an element of asymmetry to an otherwise perfectly
symmetrical building on a perfectly symmetrical site. Such perfect
symmetry can appear sterile, with symmetrically aligned elements actually
so perfectly aligned as to block each other out. The way around this is
deliberately to stand to one side of the central axis and employ a cross-front
shift movement to re-centre the image while retaining the parallel
horizontal lines. The result is a more interesting juxtaposition of the
otherwise symmetrical elements of the site, without having any of the all-
important features that lie along the line of symmetry blocked by any other.
This was the technique used in Figure 9.4, in which the central flag-pole
was symmetrically aligned with the centre of the drive and front entrance
of the building.

The third objective of cross-front shift movements when photographing
the exterior of a building is to flatten its perspective when forced to shoot
from an acute angle due to a restricted viewpoint. The camera can be turned
on the tripod to make the angle to the building less acute, and a simple
cross-front shift movement used to bring the whole building back into view
with an expanded area of the front elevation now visible due to the
flattened perspective, as demonstrated in Figure 2.5 in Chapter 2.

Figure 9.4 This photograph of the front elevation of the NETC building was taken by placing the camera to one side of the symmetrical axis of the building, and using a cross-front shift movement to deliberately add an element of asymmetry to the otherwise perfectly symmetrical site. By adopting this method the parallel horizontal lines of the building are retained as if it was taken along the symmetrical axis

Cross-front shift movements should only be slight if the appearance of normality is to be maintained. Extreme movements cause the image to appear unnatural, for example by being able to apparently produce an 'impossible' image showing the flat-on front elevation and an acute view of the side elevation at the same time. Combined cross shifts and rising shifts should be used cautiously to prevent a greater tendency toward vignetting of the image than with a single directional movement. Any such vignetting would also appear uncomfortably asymmetric.

Night shots

Night shots of buildings, at least what appear to be night shots, can be some of the most interesting and stimulating of all architectural photographs when executed carefully and with forethought (see Plate 6). They probably give us the clearest sense of the complete functional building – both exterior and interior – with the glowing room-lights enlivening a structure that may, by day, appear somewhat empty and lifeless. The combination of the cool, deep blue of the sky and the rich orange warmth of the tungsten lighting so frequently used to illuminate interiors has the effect of drawing the viewer in from the cold night outside.

Night shots actually have to be taken during a critical 20 or 30 minute period at dusk, or dawn, to overcome the film's inherent problem of recording a higher contrast than that observed by the naked eye. At these times, it is possible to retain just enough of the surface detail of the building on film, to define its structure; while the blue tone of the sky is still sufficiently bright to enable the outline of the building to be

satisfactorily silhouetted. An added advantage from the photographer's point of view is that while the colour of a clear sky is likely to be the purest, the dusk sky is always a shade of blue even on a cloudy day.

The quality and colour temperature of the natural light at dusk and dawn is the same, though the brighter glow in the sky as a result of the sun setting or rising will be in the west or east, respectively. This may have a bearing on your choice of time depending on the direction the building faces, and the angle from which you choose to shoot it. When the sun sets directly behind a building (from your chosen angle) the extra brightness in the sky can detract from the night-shot effect. Generally, it is easier to work at dusk than at dawn as one can readily see when the room-lights start to glow through the windows, relative to the daylight. It is sensible to shoot a series of shots from the start of dusk through to complete darkness, as the sky colour, the tone of the building, the brightness of the room-lights and any floodlighting are all variables throughout this period, with slightly differing effects on film. At dawn (apart from being much colder!), by the time your eyes have registered that dawn has begun, you may just have missed the perfect moment for such photography. In other words, for the purpose of creating a series of photographs throughout this period, dusk seems to be the more predictable.

Correct exposure for dusk shots is very difficult to deduce accurately, especially since the light levels, relative to each other, are constantly changing. I therefore recommend using roll film to enable a wide bracketing of exposures. Light meters produce readings that will render all subjects a mid-grey tone on film, so they tend to suggest an over-exposure for the facade of the building (unless evenly floodlit) and an under-exposure for the interior illumination. We want the building to appear dark, just retaining visible detail, with the light through the windows glowing brightly. An educated interpretation of the readings provides the best starting point for exposure, having monitored light levels since daylight. The *Kodak Professional Data Guide* suggests various trial exposures for different outdoor scenes at night. Using a film rated between ISO 64 and ISO 100, it suggests an exposure of one second at $f/4$ for floodlit buildings; $1/30$ s at $f/4$ for a skyline 10 minutes after sunset; and 4 seconds at $f/2.8$ for a skyline showing a distant view of buildings with lit windows at night. These guidelines span an eight-stop range, but can be useful references to be used in conjunction with your own educated interpretation of the meter readings. To ensure a perfect result, check exposure with instant-print film, and shoot several rolls of film, widely bracketed, throughout the half-hour period between the start of dusk and night. This way it is possible to see the full range of variable effects and gives you the option to select the perfect image for any particular usage.

Despite the low light-level conditions, I still recommend the use of a slow/medium speed film (ISO 100) for high quality results, even though this will necessitate using long exposures (typically between 1 and 10 seconds). With colour transparency film, I favour the use of daylight balanced film which both enhances the apparent warmth of any tungsten interior lighting, and renders fluorescent lighting relatively neutral (this can even be corrected using a suitable magenta compensating filter, with the effect of giving the sky colour a slightly purple hue). Tungsten-balanced film can be used, and is favoured by some photographers towards the end of dusk for a partial colour correction of any tungsten room or floodlighting. It also has the effect of making the sky colour even bluer. However, tungsten balanced film should never be used when the interior

lighting is fluorescent as this produces an unpleasant effect of blue/green room lighting.

The reason why both daylight and tungsten-balanced film can be suitable for night shots is that there is no such thing as a universally recognized neutral colour balance to which such shots should approximate (as there is, for example, with white photographic light, by day). It is a question of personal taste as to whether one prefers deeper blue dusk light with whiter tungsten lighting; or weaker blue dusk light with warmer tungsten lighting. For the same reason, there is little need to worry about compensating for any slight colour shift as a result of reciprocity failure.

Finally, always allow yourself plenty of time to prepare for taking photographs at dusk or dawn. Times of sunset and sunrise can be deduced from the 'sun finder' charts in the Appendix at the end of this book, and are generally available in daily newspapers. A visual check for several days in advance of the shoot will give you a clearer idea of likely timings under different weather conditions. Arrange for all the lights to be switched on in the building and make sure that any people inside are aware of your assignment so they do not switch off any lights just at the critical moment. It is usually possible to over-ride the timer on any floodlighting to have it switched on while still daylight to give it plenty of time to warm to its regular operating colour-temperature and brightness.

The use of people to emphasize scale

In order to demonstrate the scale of a building we need to be able to compare its size with some recognizable reference to everyday life. The simplest scale indicator is, naturally, the image of a person in the photograph from which one can easily determine the approximate scale of the surroundings.

When required to emphasize the scale of a building in this way, people can either be posed, or caught on film as they go about their daily lives. The latter involves setting up the camera, watching and waiting for a suitable juxtaposition of people in the setting already established. When using a view camera for such shots, it is essential to memorize the parameters of the image frame so you will know just by watching the scene develop, when a person or people entering the view will be suitably positioned.

Balancing primary colours

The classic combination in an image of the three primary colours (red, yellow and blue) produces a visually satisfying balance of colours, whereby the tension created by each individual colour is perfectly counterbalanced by the other two. Such a combination can occasionally be achieved in an architectural image if elements of the building being photographed are either predominantly red or yellow in colour, with a rich blue sky as the background.

For example, in the photograph of a Renault showroom (Plate 7), the contrast of the bright yellow signage against the blue sky was attractive, if a little dull. I therefore waited for a flash of red in the form of a red car driving round the roundabout to complete the primary combination for a more resolved, punchy image. Cars, people's clothing, flowers, letter-boxes and so on can all be utilized to this end.

Reflected views

Some of the most unusual and artistic effects can be generated by photographing the reflection of a building in the glass of a mirror-finished building for example, in water, or even in a car windscreen. An interesting juxtaposition of both the reflection (in the case of water or a car windscreen) and the building itself can sometimes yield a stunning result.

Using this method, I managed to find an original viewpoint from which to shoot the much-photographed Canary Wharf building in London's Docklands – see Plate 8. The distorted reflection caused by the uneven mirrored panels produce an unusual effect. Because the colours were somewhat bland in themselves, I waited for the colour, and added feature, of the Docklands light railway train in the foreground to add that necessary extra spark of interest. The tilted camera angle has introduced a powerful dynamism to the image, enhancing this abstract and artistic shot.

While such opportunities can be rare, it is always worth bearing this technique in mind for supplementary shots on an assignment. Where the building being photographed as a reflection is asymmetric in structure, or has visible signage on it, remember that both negatives and transparencies can be 'flopped' for printing, i.e. printed by projecting through the film from the 'wrong' side. This simply has the effect of correcting any back-to-front signage or the way round that the image of the building appears in the reflection.

Framing the image of a building

An element of the situation and layout of the site of a building can on occasions be used to frame the image of that building. For example, a traditional university building can be strategically viewed and photographed through an arch, adding an extra element to the final image. Likewise, a building can be framed with a window, or more commonly with trees (see Figure 10.6 in Chapter 10). While much modern architecture is photographed for dramatic graphic impact using powerful line dynamics, the inclusion of trees can add a welcoming, natural feel to a building for the purposes of marketing. This technique is probably best suited to traditional architecture which has tended over the passing years to harmonize more sympathetically with the natural environment.

Use of the fisheye lens

Fisheye lenses are basically exaggerated wide-angle lenses with extreme angles of view, typically 180° or 220°. Distinctive circular images are produced that are spherical in appearance, as a result of uncorrected barrel distortion: the vertical and horizontal lines in the image become increasingly bowed, the greater their distance from the central optical axis.

There are two basic varieties: the circular and the full-frame. The circular produces an image on film that is in the form of a full circle; while the full-frame version makes a rectangular image from within a larger projected image circle, as with regular lenses. A fisheye lens is therefore very much an 'effects' lens that is both instantly recognizable and lacking

in subtlety. As a result, its use is limited in regular architectural work, though there are occasions when its wide angle of view can usefully encompass the whole site of a large building complex (especially when used from a high vantage point). It can also be used deliberately for spectacular effect on either the exterior or interior of a building, especially when that building is symmetrical in design so that the bowed verticals on the one side of the image are perfectly mirrored on the other side. Figure 9.5(a) was taken using a full-frame fisheye lens, for a property marketing brochure, to emphasize the circular character of this unusual building. All the structural pillars have bowed, yet one is still able to get a good

(a)

Figure 9.5 Image (a) was taken using a full-frame fisheye lens to emphasize the circular character of this unusual building. By comparison, image (b) was taken using a circular fisheye lens to photograph the full extent of the construction site, from a position halfway up a crane

(b)

impression of the appearance of the whole floor space. Such an image works well in conjunction with more orthodox shots both for visual stimulation and to convey the relevant information about the interior.

By comparison, the image in Figure 9.5(b) was taken with a circular fisheye lens, from a position halfway up a crane. This lens enabled the photography of an otherwise impossible view, to show the full extent of the construction site.

A fisheye lens should be used sparingly due to its highly distinctive characteristics, and primarily for an exciting supplementary image to the distortion-free ones taken with regular lenses. Due to the high cost and rare usage of a fisheye lens, it makes sense to hire one when required rather than purchase one.

Panoramic photography

Images shot with a panoramic camera also encompass an ultra-wide angle of view, and provide an alternative to those shot with a fisheye lens (Figure 9.6). The image proportions however are quite different, usually in the proportion of approximately 3:1, producing very long, or wide, images of little height. These unusual proportions have limited use for standard publication formats, though they have a novelty value and can be effective for exhibition use.

Figure 9.6 Panoramic images encompass an ultra-wide angle of view, and provide an alternative to those shot with a fisheye lens. This 6 × 17 cm panoramic image was taken using a Linhof Technorama camera, a fixed body panoramic camera ideal for architectural work as it suffers no barrel distortion. (Photograph courtesy of Linhof)

Panoramic cameras are available in two types: the fixed body and the rotating lens varieties. The rotating lens panoramic camera is closest in effect to the full-frame fisheye, due to barrel distortion of the horizontal lines in the image caused as a result of the curved film plane. The lens is rotated and the film exposed through a slit sweeping across it just in front of the emulsion. However, unlike the image produced by a fisheye lens, the vertical lines remain vertical so long as the camera is kept level. Such distortion can be effectively corrected for viewing by curving the final print and viewing it from the centre of its radius. As such, it can be used for exhibition purposes.

The fixed body panoramic camera (the Linhof Technorama being an excellent example) is more useful for architectural work as it suffers no barrel distortion. It does however use virtually the full coverage of a 90 mm super-angulon large format lens to produce a 6 × 17 cm image on roll film. This utilizes the lens to its outer limits causing slight darkening away from

the centre of the image. This can be corrected using a centrally graduated filter. Similarly, a final alternative is to use a panoramic roll-film back on a large format camera.

Black-and-white infrared photography

For purposes of mainstream architectural photography, black-and-white infrared film is used for its unusual special effect, often as a novel theme for a creative corporate brochure (see Figure 10.5 in the next and final chapter). A print made from Kodak's High Speed Infrared film appears as a cross between a grainy, high contrast black-and-white photograph and an ethereal work of art (Figure 9.7). This is because infrared film is both sensitive to infrared radiation that is invisible to the naked eye, as well as being sensitive to much of the visible spectrum. The sun emits infrared radiation as well as light, and the ghostly images are due to the fact that many surfaces do not reflect infrared and light equally. For example, the chlorophyll in green foliage and vegetation reflects much more infrared than light and therefore appears much brighter (often white) in infrared images. By contrast, a clear blue sky reflects much less infrared, appearing darker and sometimes black in print. Accordingly, any cumulus clouds glow brightly against this dark sky, the luminescent effect resulting from grainy detail diffusion from strong reflections.

Available only in 5 × 4 in. and 35 mm formats, it has an extremely sensitive emulsion, making it very vulnerable to fogging. Even the 35 mm version can only be removed from its canister and loaded/unloaded inside a light-tight changing bag. The 5 × 4 in. film is even harder to use, prone to both fogging and scratching. Despite this extreme sensitivity, and therefore 'high speed' rating, it actually behaves as a slow film for the practical purposes of photography, with an effective film speed of around ISO 25 due to the strong filtration required to

Figure 9.7 Black-and-white infrared film is used for its unusual ethereal effect. Clouds glow brightly against a dark sky, and green vegetation is reproduced as ghostly white

achieve maximum infrared effect. While a deep red filter can be used (typically a Kodak Wratten 25 Red) at a recommended film speed rating of ISO 50 under daylight conditions, its effect on film is part daylight and part infrared. The most extreme effects· are obtained by using a visually opaque filter, typically the Wratten 87 or 87C with a recommended film speed rating of ISO 25 under daylight conditions. The Wratten 25 Red filter tends to be used for convenience of composition and focus with the filter in place. However, since architectural photographers are trained to carefully pre-plan shots and use tripods at all times, such a convenience is of little practical use. In many respects, it is simpler to compose and focus the image without the filter in place, and then place the visually opaque filter over the lens before exposing the film.

Because levels of infrared radiation do not faithfully correspond to light levels (tending to be higher in the early morning and late afternoon), light metering can only be used as an approximate guide to exposure. Exposures should be based on the ratings outlined above, and then bracketed by a series of exposures up to two stops each side of the recommended setting to take account of these variations.

Due to the longer wavelength of the infrared compared with visible radiation, the focal length of a lens is greater for infrared than it is for visible radiation. It is therefore necessary to extend the distance between the lens and the film plane by a small amount when focusing for infrared radiation. Working on 35 mm with a visually opaque filter, the lens must be focused in the normal way and then adjusted by turning the focus ring so that the focusing distance already established (for daylight) is turned to align with the tiny red spot on the f-number depth-of-field ring, on the lens barrel. This has the effect of correcting the focus for the wavelength of infrared radiation. When using a red filter, it is best to make only half the adjustment as a compromise between the wavelength of red light and that of invisible infrared radiaition, as both will be recorded on film. The increased depth of field from using a small aperture should overcome any potential problem from a slightly confused plane of focus. When using a view camera, the focusing adjustment is of the order of 0.3–0.4% of the focal length, for example, 0.3 mm for a 100 mm lens. Again, any minor inaccuracies are best taken care of by stopping the lens well down to increase the depth of field.

Aerial photography

The term 'aerial photography' conjurs up an image of taking photographs from a light aircraft or helicopter, and this is certainly true of higher altitude photography. As such, it enables unique 'whole-site' shots to be taken, and then viewed in the form of a realistic axonometric projection. It is, however, a specialist branch of photography in its own right, and beyond the scope of this manual.

In reality, the term also includes lower altitude photography which is that taken from ground-based structures at any height above eye level (Figure 9.8). Examples include shots taken from a simple step ladder, those taken from the roof of a conveniently situated building (to which access can be gained), and those taken from a hydraulic platform. Such lower altitude photography can provide an alternative perspective for architectural work,

Plate 8: Reflections of a building can offer some of the most creative opportunities to the architectural photographer. Here I managed to find an original viewpoint from which to photograph Canary Wharf in London's Docklands. The distorted reflection in the mirrored panels of another building produced an unusual effect, enhanced by the inclusion of the colourful Docklands light railway train in the foreground. For dynamic impact, the camera was tilted at an angle on its side.

Plate 9: Electronic image manipulation, using the Adobe Photoshop software package, enables a digitised image to be 'cleaned up' in spectacular fashion using the 'clone' tool.

Image (a) was the original photograph before manipulation, and for purposes of demonstration, even the car parked to the left of the main entrance, along with a metal post, has been removed in a similar fashion.

In image (b), the 'Letting' banners down each side of the building have been eliminated by replacing them with cloned brickwork.

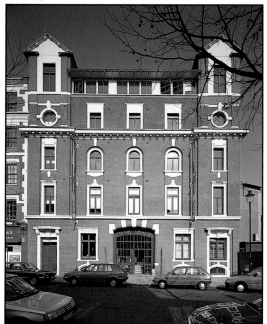

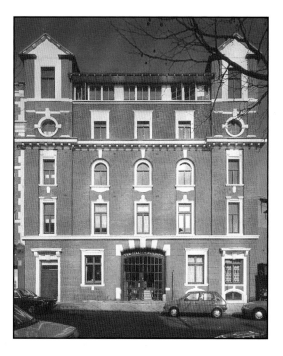

Plate 10: 'St Mary's Court' brochure. This brochure demonstrates the bold use of a dramatic abstract photograph of the reception area as the main interior illustration, along with a mixture of traditional and abstract shots to convey the atmosphere, quality and design of the property. The cover exterior detail photograph was taken at dusk, while a daylight shot of the whole building is included inside the brochure.

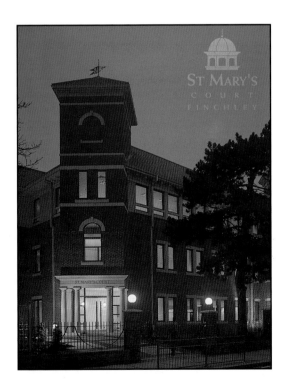

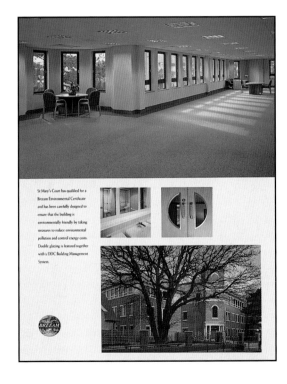

Colour Plate 11:
'St John's Place' brochure. This was the brochure for which the dramatic cover photograph of this book was originally taken. Notice how the designers have cleverly utilised the shadow area and lines of the steps at the bottom of the image in which to print the titling in bright white lettering. A more traditional view of the exterior is to be found inside, along with a mixture of general interior and abstract detail shots.

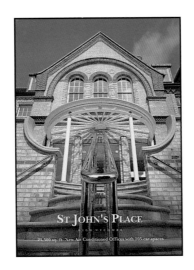

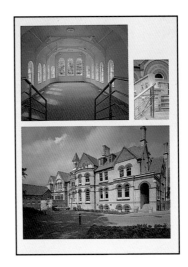

Colour Plate 12:
'Horton Industrial Park' brochure. This brochure demonstrates the possibilities that can be created from imaginative design work with a visually uninspiring building. The simple yellow stripe and yellow graphics complete the primary combination of a red-brick building and a blue sky. Furthermore, the positioning of the graphics makes excellent use of the exaggerated foreground cobbles. The additional stretched manipulation below adds an extra spark of excitement to the design input.

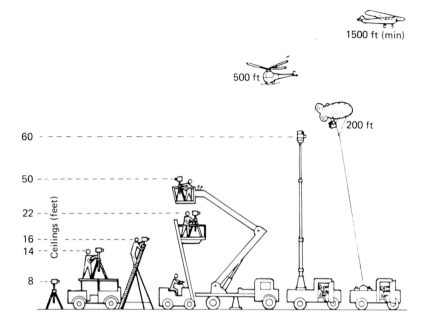

Figure 9.8 The range of options available for aerial photography

especially when photographing tall buildings which are ideally shot from a vantage point approximately a third of their height. Even working from the top of a tall step ladder, or off the roof of a motor vehicle raises the vantage point above the height of parked cars to enable you to capture a significantly cleaner image of the building.

Formatting the focusing screen

When assigned to photograph a particular building by a client it is usually for a specific purpose, often publication. The layout for the publication will either be photo-led or design-led and this should always be discussed in advance. When a publication is to be photo-led, it means that the photographer is free to photograph the building exactly as he or she chooses, in either a portrait or landscape format. However, when a publication is to be design-led, its format (typically A4 portrait, for example) will have been chosen by the designer who may even work out both the size and layout of the photographs in advance of the photography being undertaken. In these circumstances, the photographer has to produce suitable images that fit the precise proportions dictated by the design.

The best way to do this is to format the focusing screen, i.e. draw extra lines on the glass focusing screen with a fine chinagraph crayon (easily removable afterwards) of the precise proportions that the image will be used in the publication. This will enable you to both view and compose the image of the building on the focusing screen within the proportions of the layout of the publication. You will then be confident that the image you are taking will suit the proportions of the publication without having to leave the decision to your powers of approximate judgement.

A practical way to format the focusing screen (assuming the published image shape is to be rectangular) is outlined below. First, trace the image area of the focusing screen onto tracing paper, and cut it out so you end up with a tracing-paper replica of the focusing screen. Second, draw up the precise dimensions that the image will appear in the publication, on a separate piece of paper. Third, draw a straight diagonal line from the bottom-left corner to the top-right corner, as shown in Figure 9.9. Fourth, place the tracing-paper replica of the focusing screen in the bottom left-hand corner of the sheet of paper, and trace the diagonal onto it. The point at which the diagonal comes off the edge of the tracing paper is the point at which you must draw a line at right-angles to that edge. This will give you the scaled down proportions of the publication format. Fifth, cut this new format out of the tracing paper, and centre it over the focusing screen. With a chinagraph crayon draw lines on the screen to correspond with the edges of the tracing paper. The focusing screen is now formatted for the specific proportions of the image in the publication for which the photograph is to be taken.

Figure 9.9 Formatting a 5 × 4 in focusing screen for A4 proportions. Step 1: draw a diagonal line from the bottom-left to the top-right corner of an A4 sheet of paper. Overlay a tracing paper replica of the focusing screen in the bottom-left corner, and trace the diagonal onto it. Draw a line down to the base of the tracing paper from the point where the diagonal crosses its edge, and cut along this line. Step 2: centre the tracing-paper over the focusing screen and mark the outline of the new format with a chinagraph crayon

Electronic imaging

Electronic imaging has become probably the most revolutionary develop-ment in the whole history of photography since its invention, opening up a vast range of potential opportunities for photographers, publishers and printers, hitherto unforeseen. The silver halide process of photography is being challenged for the first time. While electronic imaging can and does successfully work with conventional film (and can indeed enhance images taken on such materials), I believe it will ultimately threaten it with extinction. The demise, however, will be a while in coming for reasons outlined below.

The term 'electronic imaging' encompasses the entire process of generation, storage and retrieval of images by electronic means. Digital imaging is perhaps the most significant element of the electronic imaging process, and refers to the breaking up of an image into thousands of 'pixels': the smallest distinct units of a digital image that are encoded with the varying intensities of the colours red, green and blue that make up the image. The image can either be photographed in digital form using, for example, a Leaf Studio Camera Back, or shot using conventional film which requires the transparency or print to be digitized using a scanner. For purposes of architectural photography, conventional film is currently the favoured option, as the generation of images in digital form involves viewing them on a colour monitor. The need for an electricity supply, plus the extra bulk and weight, makes this an impractical alternative for most location photography, though no doubt a desirable option for studio work.

However, the potential for scanned digital images is immense. High resolution digital images can be stored in a variety of ways: on CD-ROM disks, Kodak Photo CD disks, or on a hard disk, enabling the viewing and manipulation of the digitised image on a computer screen. It is this manipulation facility that holds the major key to the revolutionary potential for photographers. Using the popular Adobe Photoshop software package, available for both PC and Apple Mac users, the digitized image can be enhanced or 'cleaned up' in spectacular fashion using the 'clone' tool. By replicating a portion of an image, this tool can retouch any image with startling effect. This was the tool used to 'clean up' the image shown in Plate 9. The 'Letting' banners down each side of the building have been eliminated by replacing them with cloned brickwork. For purposes of demonstration, the car parked to the left of the main entrance has been removed, along with an unsightly metal post, with the brickwork, gate, pavement and road having been cloned to replace it. The whole process, including scanning and printing, took about one hour with a skilled operator. Other facilities include colour correction, shade control, and cut and paste options for creating montages.

Once manipulated, there are three main options for image output: output to print via a digital dye sublimation printer; output to film; or output to digital file on a CD-ROM or photo CD disk, for example. Output to digital file will increasingly be the favoured option for purposes of publication, as this avoids the need for the publisher to further scan the image. Output to some form of digital file also combines well with the growth in desktop publishing whereby images can be directly slotted into the publisher's layout on computer screen.

My experience is that the end-users of photographic images – the designers and publishers – have been the first to take up both the use and

expense of these facilities. However, in the coming years I suspect the expectation of the end-users will be for images to be supplied in digital form, on CD-ROM or photo CD. While conventional film may still be the chosen medium for image generation in location work, photographers will be expected to submit their work on disk. There will undoubtedly be growing numbers of laboratories or service bureaus offering scanning facilities, though with potentially lower costs as a result of ever-increasing demand and improved technology, I imagine some photographers will soon choose to invest in a scanner, a manipulation software package, and a CD-ROM writer on a personal computer to produce their own disks.

10

An analysis of brochure design and photography

Introduction

The aim of this final chapter is to demonstrate the practical application of architectural photography for purposes of publication. There is a mixture of applications, from purely architectural (for promoting the work of the architect), through commercial property brochures, to magazine covers. The emphasis is on property brochures as these are neat vehicles for displaying full coverage of most aspects of a building, both exterior and interior. They also tend to be designed and printed to a high standard as quality promotional material for the purpose of marketing a commercial building. As such they provide useful portfolio material for the photographer.

In this chapter I have attempted to analyse a selection of publications for which I have been responsible for the photography. Successful brochure design is the result of a creative synthesis of the work of both designer and photographer, working together on a given project. The photographer must have as clear an idea as possible of the designer's intentions, and the designer must retain sufficient flexibility in order to make the best use of the photographs supplied.

Analysis

Looking generally at the following selection of brochures I noticed that where I have exercised my creative licence to produce abstract or dynamic shots from unusual angles, designers have chosen to give these images a deserved prominence over and above the necessary, but more conservative ones. This is noteworthy as often these shots have not been part of the brief for the job, but have stood out as having greater impact than images taken from more traditional angles, while still conveying the important essences of the buildings concerned.

Centre Court, Wimbledon

A good example of my creative licence being given prominence in the design of a brochure is the cover shot for the 'Centre Court, Wimbledon' shopping centre brochure (shown in Figure 10.1) which had been completely unplanned, but was irresistible to take. The anticipated cover shot had been a more general view of the exterior of the centre with plenty of people walking by. In the end this general view was effectively used in ghostly outline inside the brochure as a background to the text, maps and other images. The dramatic abstract shot of the sculpture outside the centre has been used cleverly to work both as a portrait A4 cover (which can be

Figure 10.1 Centre Court, Wimbledon

seen by covering over the left-hand half) and as a landscape A3 spread covering the front and back cover as displayed here.

The inset shots inevitably show busy shoppers and national store names to attract further retailers to the centre. The photograph top right on the inside shows a semi-abstract view of the interior, showing both shoppers and people in the cafe amidst a clean architectural setting. Such centres tend to offer exciting vantage points from different levels. The photography in this brochure took one day to shoot.

St Mary's Court

Following on the abstract theme, I was thrilled that the designers chose an equally dramatic shot for the main illustration inside the St Mary's Court brochure (see Plate 10). This time it was the view from a balcony overlooking the reception area, with the camera tilted for maximum line dynamics. This viewpoint emphasizes the unusual lighting that is a feature of the interior, which had become somewhat lost and lacking in impact in the more reserved shot inset, that was taken from ground level. Further detail shots can be seen in the smaller pictures inside conveying the atmosphere, quality and design while leaving the site and floor plans to convey the necessary practical information.

The cover shows the potent use of a night shot (taken at dusk), with the gold border deliberately designed both to resonate with the orange tungsten glow from the reception lighting, and to contrast with the purple hue of the evening sky. A slight mist (unplanned!) served to enhance the glowing effect of the ball-lights on the entrance pillars.

This folded triple-A4 format provided plenty of scope for photography, the work shown here taking about one-and-a-half days to complete. As the brochure is opened you see the dramatic reception shot on the left, with the more traditional shots of both an office floor and the full exterior, on the right. There are also two further detail shots showing the quality of the bathrooms and the design of the doors. This page then opens again to reveal the triple spread previously discussed. The back page of the brochure (not shown) was filled with location plans and agents' details.

Langham Gate

Another example of a successful night shot is in the opening spread of the Langham Gate brochure, in Figure 10.2 (no photographs were used for the cover itself). Although the brochure is portrait in design when closed, each open spread is just landscape with the proportions 34.5 × 29.5 cm. The use of a night shot (again taken at dusk) showed off this refurbished building with its unusual canopy and floodlighting to its best advantage. Note the importance of the uniformity of detail in such a shot, with all windows closed and all lights switched on. This photograph, in terms of both size and positioning, was carefully juxtaposed with a daytime detail shot of the front exterior from the opposite direction. Both shots are angled inwards towards the middle of the brochure to hold the attention of the viewer. Running in wave-form along the bottom of each spread of this brochure are various abstract shots that express the atmosphere of location and environment in which the building is situated.

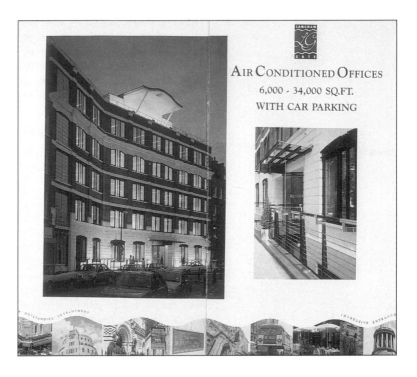

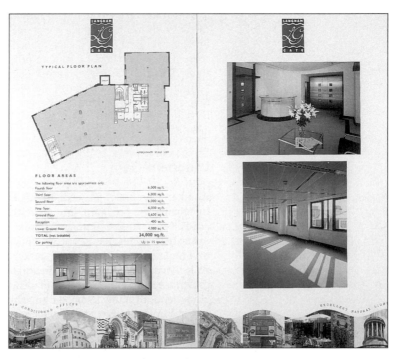

Figure 10.2 Langham Gate

The final double page spread of this brochure shows an interior shot of the reception, brought to life by the inclusion of fresh flowers and newspapers. It also shows some of the open-plan office space, deliberately photographed to avoid showing any structural pillars and for the sunshine patterns to fill the otherwise empty and dull floorspace. The small image on the left was necessary to show another aspect of the available office space. It was taken using a long exposure without fill-in flash in order to 'burn out' as much as possible of the external view of the unattractive building opposite, to create the appearance of bright natural light in the interior which actually does not exist.

Marylebone Lane and The Galleria, Crawley

The covers for Marylebone Lane and The Galleria, Crawley are two different successful approaches to the use of exterior entrance shots when the building as a whole is either awkward to photograph in terms of a cramped location, or unsuitable for some other reason. The Marylebone Lane entrance was photographed on an overcast day using an 81B filter to 'warm up' the colours. Due to the relatively low intensity of the daylight, the interior tungsten lighting appears to glow brightly, drawing the viewer in. The symmetrical image has been used symmetrically on the page with the number '9' above the door in the image being cleverly utilized as the only indication on the page as to the street number of the building. The treatment is simple, smart, clean and effective for the quality of the building concerned.

By contrast, The Galleria cover is produced in landscape format, with the designwork deliberately breaking the symmetry initiated by the photograph. This is necessary due to the large proportion of the cover that the photograph fills. Without such an asymmetrical layout to stimulate the attention of the viewer, the domineering symmetrical photograph could cause the cover to appear sterile and unimaginative.

Figure 10.3 Marylebone Lane and The Galleria, Crawley

Finally, notice how such simple symmetrical shots have to be perfectly executed to be effective. They have to be precisely centred, with the film plane parallel to the elevation of the building, and the verticals absolutely perfect to stand out boldly and avoid connotations of trite simplicity.

St John's Place

Designed by the same company as the St Mary's Court brochure, and for the same client, the cover of the St John's Place brochure (illustrated in Plate 11) is another good example of a symmetrical treatment. This time, however, the image has added drama from the low vantage point and deliberately tilted camera angle which has caused the verticals in the image to converge. The entrance to this old grammar school, converted for use as offices, has been brilliantly designed to play on the circular motif initiated in the contrasting brickwork of the building. The canopy, the steps and the handrail all mirror this motif to some degree with very satisfying visual effect. In terms of brochure design, the designers have cunningly utilized the shadow area and lines of the steps at the bottom of the image in which to print the title and location of the building in bright white lettering. The result is a good example of an effective synthesis of the talents of architect, photographer and designer in creating an impressive modern brochure of an otherwise attractive, but traditional, building. The regular angled elevation shot appears inside the brochure, on first opening, on the right-hand page. The brochure then opens further to the triple-A4 format again, with the main reception shot (with inset of the opposite view) filling two of the three sides. The final shot on this spread is an abstract view down the modern stairwell, taken at that angle for maximum line dynamics. Similar to the St Mary's Court brochure, the photography time was again a day-and-a-half.

Nissan European Technology Centre

Aspects of the Nissan European Technology Centre (NETC) have been featured throughout this book as a loose theme on which to illustrate various points. Figure 10.4 shows a small selection of images and their layouts made by the architects of The Alan J Smith Partnership for the purpose of their promotional brochures. In combination, this set of photographs spans the wide variety of demands made on the architectural photgrapher, from the dominant angle shot of the front elevation of the building, spreading across one-and-a-third of the large (30 × 30 cm) square pages, through abstract and semi-abstract exterior detail shots, to a detail shot of the reception desk inside. The variety of vantage points from distant to close-up; the variations in size, and in format between landscape and portrait; and the combination of exterior and interior shots make these a representative selection from a comprehensive collection of images.

Property agent corporate brochure

The brochure illustrated in Figure 10.5 demanded a fairly radical departure from the usual requisites of architectural photography. Being a corporate brochure, there was much freer licence to be artistic with the interpretation

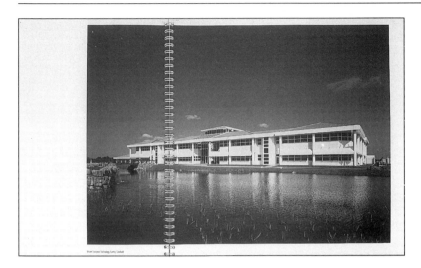

Figure 10.4 Nissan European Technology Centre

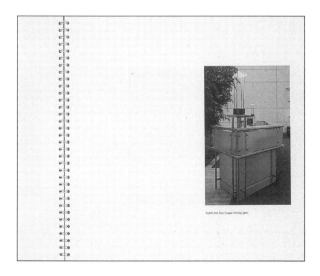

Figure 10.5 Property agent corporate brochure

of the buildings than with marketing brochures where clarity of detail is essential in order for the viewer to be able to understand the potential of the building. As a result, a theme was adopted whereby the four main images, to fill the right-hand page of every spread, would be abstractions shot at an angle on black-and-white infrared film with different colour washes over each image (the washes were added at the brochure printing stage). One of the spreads is shown here, each page being a large square format (30 × 30 cm). To supplement the infrared images, small, regular colour shots were interspersed with the text on the left-hand pages.

Traditional Homes magazine and Manchester Square

The two covers illustrated in Figure 10.6 are both examples of how traditional architecture can be successfully photographed using the tree-framing technique outlined in the last chapter. They serve to demonstrate how older styles of architecture blend comfortably with their natural environment. As such, this treatment was especially appropriate for the

Figure 10.6 *Traditional Homes* magazine and 'Manchester Square'

Traditional Homes magazine cover, and also provided a suitable back-cover shot, taken from within the leafy square, for the Manchester Square brochure. The front-cover shot is striking for its clean lines and bright white paint against the rich blue of the sky, and as such is a clearer image of the building, important for the purpose of this brochure. The cover has been designed with a dark-green base, enabling the image to shine through brightly as if looking through a peep-hole at a brighter world.

Horton Industrial Park

As a final brochure illustration, it seemed appropriate to show the imaginative design treatment that can be given to boost the appearance of a brochure for an otherwise mundane building. Part of the workload of any architectural photographer will inevitably involve photographing such buildings, and so it is interesting to see a good example of the design potential available in these circumstances. The simple two-sided A4 brochure illustrated in Plate 12 is a good example of a well-designed property brochure from an otherwise uninspiring shot of an uninteresting industrial building.

First, by simply adding the yellow stripe down the left-hand side, and working with a combination of blue and yellow graphics on an overwhelmingly red-brick image, the designer has successfully resolved a balance of primary colours on this brochure cover, to pleasing effect as discussed in Chapter 9. Furthermore, the graphics have been thoughtfully laid out to utilize the exaggerated brick-cobbled space in the foreground. Finally, to add extra interest and design input, a weaker stretched manipulation of the image has been used underneath as a backdrop for further relevant text.

The above illustrations demonstrate a wide variety of the kind of applications for which architectural photography is undertaken. My idea is that these examples may yield an understanding of the potential available in terms of brochure design which can be helpful to keep in mind when taking the photographs. They also serve as an illustration of the type and variety of shots that are required for integration into a comprehensive property brochure.

Appendix: 'sun finder' charts

Introduction

These ingenious 'sun finder' charts on pp. 112–14 were originally published in *The Professional Guide to Photo Data* by Richard Platt (Mitchell Beazley, 1991). Incredibly, they enable you to find both the direction and elevation of the sun at any location between the Arctic and Antarctic circles, at any hour on any day of the year. Accordingly, they also show the times and directions of sunrise and sunset. Although the charts may look daunting, they are actually not difficult to use, especially if you require only approximate guidance.

To be able to estimate the direction and elevation of sunshine on a building at any particular time of day is of critical importance to the planning schedule of any architectural photographer. The direction and timing of sunrise in the UK varies from approximately north-east at 04.00 hours in mid-summer to approximately south-east at 08.00 hours in mid-winter (as was simply illustrated in Figure 6.5 in Chapter 6). Likewise, sunset in the UK varies from approximately north-west at 20.00 hours in mid-summer to approximately south-west at 16.00 hours in mid-winter. Hence, the midday elevation of the sun is much lower in winter and much higher in summer. These are very significant variations especially for north-facing buildings which are only ever directly illuminated by a summer sun. It is equally significant for those buildings in confined city areas where a high elevation of the sun is necessary for it to shine over the top of the surrounding buildings.

Sunrise and sunset information is readily available in daily newspapers for the here and now, but for other locations around the world, and for dates in the future, the information is much harder to track down.

Guidelines for using the 'sun finder' charts

The following guidelines will enable you to locate the approximate position of the sun. For greater precision, you will need to make the corrections listed in the next section.

1 Establish your approximate latitude and find the correct chart. It does not matter for the time being whether you are north or south of the equator.

2 Read the date table to pick your date line (A–Z) and find that line on the chart.

3 This line represents the sun's path across the sky for the week you have chosen. The horizontal axis represents the horizon, with the points of the compass, N, S, E, and W, running across the scale. The elevation (height above the horizon of the sun) is marked on the vertical axis.

4 The curving line represents hours of the day – morning on the left and afternoon on the right. Where the date line cuts the horizontal axis, you can read off the rising and setting times. These lines do not take into account daylight saving. If daylight saving is in operation, the sun will rise and set 1 or 2 hours later than indicated on the chart.

You will notice that all charts have two sets of compass points on the horizontal axis. This is because when the sun is overhead at the equator it appears to be in the south of the sky to everyone in the northern hemisphere, whereas those in the southern hemisphere see the sun in the north. Between the tropics, the situation is a little more complex, but if you follow the boxed directions you will always be able to find the right scale.

Corrections for greater accuracy

These charts are limited in their accuracy to about 5°, or 20 minutes of time. Corrections need to be made to locate the sun's position with greater precision. Probably the most crucial of all is your position in the time zone. The hour lines on the chart represent the time approximately as it would be indicated by a sundial, so the sun reaches its zenith exactly at noon. However, the world's time system is far more complex than this, and is organized in zones 1 hour apart.

Within each zone clocks are set to read noon when the sun reaches its zenith at the centre of the zone. However, some time zones are very wide and, in extreme instances, the sun may rise 2 or 3 hours later in the west of the time zone than it does in the east. The easiest way to compensate is to consult an atlas and calculate how many degrees of longitude separate your location from the Greenwich meridian. Divide the number of degrees by 15 to find out how many hours behind or ahead of Greenwich your true local noon is. Compare this with official local time to determine the necessary correction.

Two further corrections may be necessary for greater accuracy. First, the times shown are most accurate when the sun is observed over the sea. At other places, the horizon is higher and the time of day correspondingly shorter. Second, if you are using a compass to find north, remember that for precise readings magnetic north is not quite the same as true north. The difference changes year by year, and can be checked on a recent map.

Finally, plotting a hemisphere onto a flat piece of paper inevitably introduces distortions. The projection used here is accurate for the horizon, but since the points of the compass converge on the zenith, the scale of degrees gets progressively more distorted the higher the sun is in the sky. This does not actually introduce an error but simply means that the charts give the sun's direction with less precision at noon than at dusk and dawn.

Projection distortions

Plotting a hemisphere onto a
flat piece of paper inevitably
introduces distortions. The
projection used here is accurate
for the horizon, but common
sense shows that, since the
points of the compass converge
on the zenith, the scale of
degrees gets progressively more
and more distorted the higher
the sun is in the sky. This does
not actually introduce an error –
it simply means that the charts
give the sun's direction with less
precision at noon than at dusk
and dawn.

Date lines

Closest date	Hemisphere N	S
December 31	A	Z
January 7	B	Y
January 14	C	X
January 21	D	W
January 28	E	V
February 4	F	U
February 11	G	T
February 18	H	S
February 25	I	R
March 4	J	Q
March 11	K	P
March 18	L	O
March 25	M	N
April 1	N	M
April 8	O	L
April 15	P	K
April 22	Q	J
April 29	R	I
May 6	S	H
May 13	T	G
May 20	U	F
May 27	V	E
June 3	W	D
June 10	X	C
June 17	Y	B
June 24	Z	A

Closest date	Hemisphere N	S
July 1	Z	A
July 8	Y	B
July 15	X	C
July 22	W	D
July 29	V	E
August 5	U	F
August 12	T	G
August 19	S	H
August 26	R	I
September 2	Q	J
September 9	P	K
September 16	O	L
September 23	N	M
September 30	M	N
October 7	L	O
October 14	K	P
October 21	J	Q
October 28	I	R
November 4	H	S
November 11	G	T
November 18	F	U
November 25	E	V
December 2	D	W
December 9	C	X
December 16	B	Y
December 23	A	Z

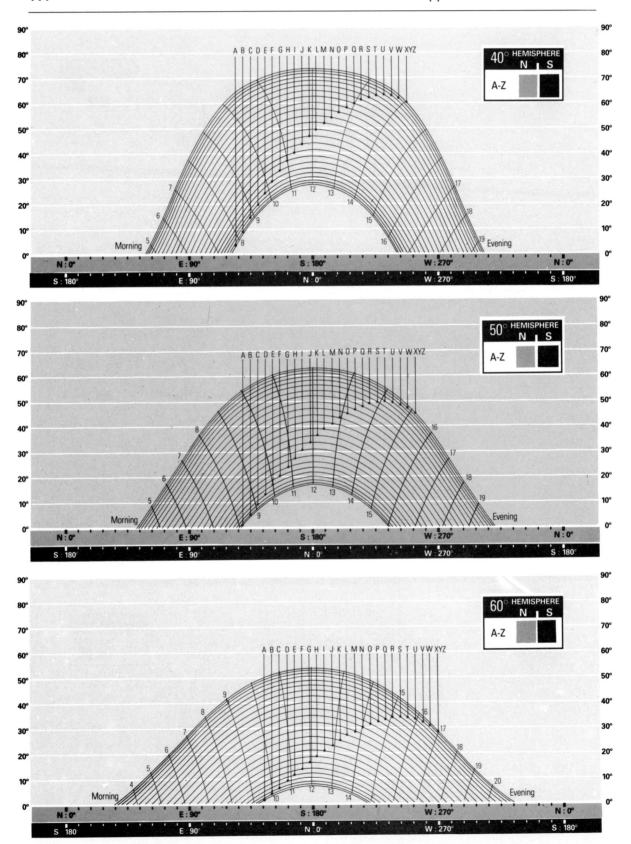

Glossary of architectural terminology

Alcove: a vaulted recess in wall of room

Architrave: the moulded frame surrounding a door or window

Atrium: an inner court open to the sky, these days usually glass-covered

Axis: an imaginary straight line passing centrally through a building to give an impression of balance

Axonometric projection: geometrical drawing to show bird's eye-view of building in three dimensions. The plan retains its true angles and dimensions, but is set at a convenient angle (typically 60° and 30°) with verticals drawn vertically to scale

Canopy: a roof-like projection over a door or window

Capital: the head of a column

Cladding: an external covering applied to a building for aesthetic or protective purposes

Classicism: a revival of the principles of Greek or Roman architecture

Cornice: the projecting ornamental moulding along the top of a building or internal wall

Course: a continuous layer of bricks in a wall

Cupola: a small dome on a roof

Elevation: the external face of a building

Facade: the front face of a building

Facing: the finishing applied to the outer surface of a building

Fenestration: the arrangement of windows in a building

Gable: the triangular piece of wall at the end of a pitched roof

Gazebo: a summer-house with a wide-open view

High tech: an approach to architecture based on construction technology and its visual expression. Developed in the 1970s by English architects (notably Norman Foster and Richard Rogers), their buildings are characterized by their exposed structures and services

Isometric projection: a geometrical drawing showing a building in its three dimensions to give the illusion of perspective, but with all vertical and horizontal dimensions accurately scaled. The angles of the building are set at 30° to the horizontal

Lintel: the horizontal beam or stone spanning the opening of a door or window

Location plan: a map showing the location of a building within the local area

Mezzanine: an intermediate storey

Moulding: a slender, ornamental continuous projection

Parapet: a low protective wall along a house-top, balcony, bridge etc

Pedestal: the base supporting a column

Perspective: the effect of things getting smaller as they recede into the distance. A perspective drawing is simply a visual impression of how a completed building is likely to look

Plan: a map of a building showing a horizontal plane cut through a building just above ground level in order to show the position of doors, windows, internal walls etc

Portico: covered colonnade at entrance to a building

Precast concrete: concrete components that have been cast in a factory before being placed in position on site

Profile: the contour or outline of a building

Proportion: the ratio of different parts of a building to the whole

Reinforced concrete: concrete reinforced with steel to take the tensile stresses of a beam

Rendering: the plastering of an external wall

Scale: a comparison of relative size. With architecture, this size can be relative either to ourselves or to other buildings

Section: a diagrammatic drawing of a vertical plane cut through a building

Site plan: a map showing the layout of a building on its plot of land

Street furniture: benches, bollards, lamp-posts, letter-boxes, telephone kiosks etc

Terrace: a row of attached houses, flat-faced and flush with those on either side

Trim: the framing of features on a facade

Vault: an arched ceiling or roof of stone, brick or concrete

Vernacular architecture: traditional buildings in indigenous styles constructed from locally available materials and not architect designed

Working drawing: one specifically drawn up for the builders, plumbers, electricians etc. with accurate details for their particular jobs

Bibliography

Buchanan, Terry (1984) *Photographing Historic Buildings*, Her Majesty's Stationery Office.

File, Dick (1991) *Weather Facts*, Oxford University Press.

Fleming, John; Honour, Hugh and Pevsner, Nikolaus (1991) *The Penguin Dictionary of Architecture*, Penguin Books.

Freeman, Michael (1990) *Collins Photography Workshop: Film*, Collins.

Freeman, Michael (1990) *Collins Photography Workshop: The Image*, Collins.

Freeman, Michael (1990) *Collins Photography Workshop: Light*, Collins.

Harris, Michael (1993) *The Manual of Interior Photography*, Focal Press/Butterworth-Heinemann.

Hartas, Darron (1993) *Back to Basics*, The Imaging Centre, KJP.

Hawkins, Andrew and Avon, Dennis (1984) *Photography: The Guide to Technique*, Blandford Publishing.

Jacobson, Ralph E.; Ray, Sidney F. and Attridge, Geoffrey G. (1988) *The Manual of Photography*, Focal Press/Butterworth-Heinemann.

Kodak (1984) *Kodak Professional Data Guide*, Kodak.

Langford, Michael (1986) *Basic Photography*, Focal Press/Butterworth-Heinemann.

Langford, Michael (1989) *Advanced Photography, Focal Press/Butterworth-Heinemann.*

McGrath, Norman (1987) Photographing Buildings Inside and Out, Focal Press/Butterworth-Heinemann.

Oliver, Paul and Hayward, Richard (1990) *Architecture: An Invitation*, Basil Blackwell.

Platt, Richard (1991) *The Professional Guide to Photo Data*, Mitchell Beazley.

Reynolds, Clyde (1984) *Lenses*, Focal Press/Butterworth-Heinemann.

Shaman, Harvey (1991) *The View Camera*, Amphoto, Watson-Guptill Publications, New York.

Simmons, Steve (1992) *Using the View Camera*, Amphoto, Watson-Guptill Publications, New York.

Smithies, K.W. (1981) *Principles of Design in Architecture*, E. & F.N. Spon.

Turner, Kevin (1993) *Converging Problems*, Professional Photographer, November 1993, 19–20.

Ward, T.W. (1991) *Composition and Perspective*, Magna Books.

Wilson, Francis and Mansfield, Felicity (1985) *Spotter's Guide to the Weather*, Usborne Publishing.

Index